CHRISTMAS *at* Miller & Rhoads

CHRISTMAS *at* Miller & Rhoads

MEMOIRS OF A SNOW QUEEN

DONNA STROTHER DEEKENS

Charleston London

THE
History
PRESS

Published by The History Press
Charleston, SC 29403
www.historypress.net

Copyright © 2009 by Donna Strother Deekens
All rights reserved
Pen-and-ink illustrations by Brenton Deekens.

First published 2009
Manufactured in the United States

ISBN 978.1.59629.765.4

Library of Congress Cataloging-in-Publication Data
Deekens, Donna Strother.
Christmas at Miller & Rhoads : memoirs of a snow queen / Donna Strother
Deekens.
p. cm.
Includes bibliographical references.
ISBN 978-1-59629-765-4
1. Deekens, Donna Strother. 2. Miller & Rhoads--History. 3. Miller &
Rhoads--Employees--Biography. 4. Department store Santas--Virginia--
Richmond--Biography. I. Title. II. Title: Christmas at Miller and Rhoads.

HF5465.U64M5544 2009
394.2663--dc22
[B]
2009038612

*In loving memory of my parents, Evelyn and Mike Strother,
whose love of Christmas and Miller & Rhoads, and encouragement and
support for their daughter as a "Snow Queen," served as an inspiration
to make this book possible.*

Contents

List of Illustrations

All pen-and-ink illustrations by Brenton Deekens

Preface

Christmas at Miller & Rhoads: Memoirs of a Snow Queen is a project I have envisioned writing for years. With the sad demise of the downtown department stores in Richmond and nationwide, we must chronicle the influence and importance of such a time.

People who remember the days of Miller & Rhoads say there will never be anything like it again. For children and adults, visiting the store at Christmas was a holiday tradition. Indeed, there was no other time of year like Christmas in Richmond, and there was no other place like Miller & Rhoads.

Little did I know that a job I began in 1971 as the "Snow Queen" would last twenty years and have such an impact on my life. It was a privilege to be part of the history of Richmond's Miller & Rhoads and the *real Santa*.

I am grateful for the fond place that has been reserved for Santa and the Snow Queen in people's hearts. In this endeavor, I seek to capture the warm feelings reminiscent of that bygone era of the store. Through my stories and the recollections of numerous others who generously shared their treasured memories, I strive to again, create *the magic*.

Acknowledgements

I am indebted to many people for this work about Christmas at Miller & Rhoads. Among them are George Bryson, Earle Dunford, Brenton Deekens, Greg Deekens, Judy Jones, John Wilkinson, Laura All, Milton Burke, Charles Nuckols, Dan Rowe, Frances Hood, Carolyn Drudge, Tony Turner, Marc Goswick, Cullen Johnson Jr., Ritchie Johnson, Bobbie Kay Wash, Beverly Edwards, Carol Schlichtherle, Janet Pritchett, Ann Dickinson, Betty Dementi, Bill Martin, Meg Hughes, Suzanne Savery, John D. Clarke, Stuart White, Sandra Ball, Allen Rhodes, Laney Caston, Michael Lisicky, Eric Verschuure, Frances Verschuure, Mary Louise Johnson, Donna Hudgins, Dennis Wrenn, Judy Wrenn, Deborah Crawford, Lila Gammon, Michael Jones, Amy Jones, Catherine Boone, Nancy Emerson, "The Cheryl Group," June Adams, Cindy Ford, Sharon Garber, Christy Martin, Don Spriggs, Gale Spriggs, Dottie Mears, the Gonner family, Pat Carreras, Vaughan Gary, Harriett Heath, Gail Brookings, Jody Weaver, Ron Jones and numerous others who contributed photographs, anecdotes, recollections and encouragement. Extra thanks to my patient and wonderfully supportive husband, Bill Deekens.

Any errors, of course, are the sole responsibility of the author and not those who gave their assistance.

BCD,109

A Childhood Dream Becomes
the Perfect Christmas Job

Almost every little girl dreams of being a princess or a queen at one time or another, and I was no different. My dreams as a child were etched in fantasy and just as lofty as all childhood expectations. This perception seemed to be especially true in the 1950s, when the world appeared more innocent and less complicated.

I am of the Baby Boomer generation, the middle child of three siblings and a product of two loving parents. We were the typical middle-class American family—my dad was a navy veteran of World War II and my mom was a devoted wife and mother. After the war, Dad was employed by Western Electric. The family settled in Cradock, a historic area in Portsmouth, Virginia. My older sister, younger brother and I spent our early years there. It was a wonderful place to grow up. That is where we molded our family traditions and formed lifelong friendships. As I recall, that is where my youthful, imaginative adventures began.

It was by word of mouth that we learned of the "magical experience" at the Miller & Rhoads department store in Richmond. Like so many families in the Tidewater area, we made the two-hour trip during the Christmas holidays to visit the *real Santa* there. We established this tradition and continued it every year. Many folks throughout Virginia, North Carolina and other states made similar holiday excursions to Richmond.

It was a treat to make our day trip to Richmond, usually on a Saturday. Our excitement would steadily grow as we anticipated

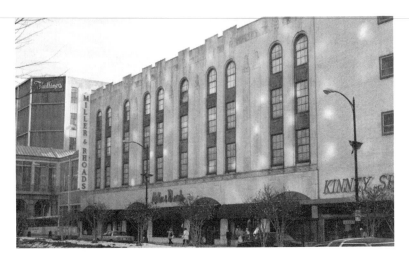

Miller & Rhoads exterior, Broad and Sixth Streets, the final Christmas season, 1989. *Michael Lisicky Private Collection.*

seeing Santa Claus, the Snow Queen and the Elf. Each year, our destination was the seventh floor and Miller & Rhoads's Santaland. There, the Old Dominion Room was transformed into an enchanted world. We knew this was Santa's "home" for the holidays, and it beckoned visitors of all ages.

Most guests from previous years knew that the Santaland waiting line would be at least a two-hour wait and probably longer, especially on a Saturday. Our hearts would beat faster and faster as we inched our way in the winding line filled with little girls in crinoline dresses and little boys in Peter Pan–collared shirts and bow ties. Finally, we would arrive at the front of the line, first talking with the beautiful Snow Queen and then meeting with the bigger-than-life Santa.

The wait was sometimes tiring, but it was something we knew we had to endure, for the reward was worth it—a visit with him—the *real Santa*. And, how did we know he was the *real Santa*? Because this Santa not only looked like the tradition of the true jolly 'ole Elf, but he also made a personal connection with each child. He knew our names without our telling him and without our parents or anyone in the room announcing to him who we were. He always seemed

to remember us from year to year. And, as we keenly observed, he "knew *all* his boys and girls," as he would say.

Many years later, I would learn from my dad that somehow he had "communicated" with the real Santa during those childhood visits. According to Dad, it seemed in some manner that Santa, perhaps clairvoyantly, learned that our last name was Strother, which was also his last name. Dad said that Santa asked him where our Strother family line had originated. They both concurred that we were "probably related"; however, to this day I do not know how all of this discussion was carried out so discreetly. Nevertheless, I always thought how ironic it was that years later I would become a Snow Queen, my maiden name being Strother and perhaps related to that very famous Santa.

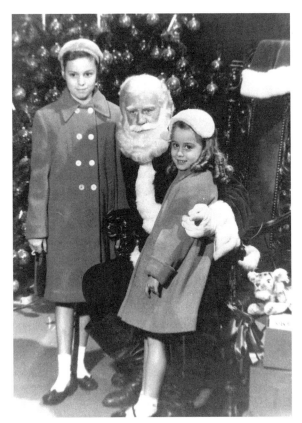

Judith Strother Jones (left) and Donna Strother Deekens visit the *real Santa* at Miller & Rhoads, 1956. *Bill and Donna Deekens Private Collection.*

Following our visit, we were ready to enjoy a meal in the Tea Room. Still elated from seeing Santa and his helpers, we hopped on the elevator, feeling as if we were floating down to the fifth floor, where the Tea Room was our destination. As we exited the elevator, the hallway wound around and turned to the left.

We made our way toward the entrance and initially were greeted by a stately, strikingly decorated Christmas tree. It sparkled cheerfully, seemingly welcoming all who entered. Crowds were directed to form three lines under the large "Tea Room" sign, quickly filling spaces with hungry children and weary parents. (No Tea Room reservations were accepted for lunch or dinner with Santa.)[1]

After another extensive wait, we were at last seated near the Tea Room stage. This was especially exciting because we knew that we would be dining near Santa, the Snow Queen and the Elf, who would arrive and sit on the stage to enjoy their lunch. Then, of course, the highlight of the meal was "Rudolph cake" for dessert. It was made by that famous reindeer himself and distributed by Santa to all the children. Another special tradition was listening to the renowned musician Eddie Weaver play familiar Christmas tunes on the organ.

After lunch and some shopping, we would be sure to allow time to gaze in amazement at the beautifully decorated windows at both Miller & Rhoads and the neighboring retail competitor, Thalhimers, located across the street. My sister Judy and I would "judge" the windows, pointing out our favorites, which usually were animated and festive.

In 1963, it was a surprise when my dad accepted a promotion with the Chesapeake and Potomac Telephone Company, which resulted in a move to Richmond for our family. Of course, we continued our Christmas visits to Miller & Rhoads, and the move afforded us the opportunity to shop there year-round. As I grew into my teens, Mom would allow me to ride the bus downtown to shop with a few of my friends by ourselves. We considered this a true rite of passage.

While attending Douglas Southall Freeman High School, I enjoyed being a representative of the school to the Thalhimers Deb Council, a "teen modeling council" for that retailer's downtown location. Miller & Rhoads had its own group of teenage models,

"the M&R Teen Board," plus a lovely entourage of older models who showcased the latest fashions in the Tea Room. (Later, I would be kidded by some friends that I had first "worked for the competition!")

After graduating from high school, I enrolled as an undergraduate at Westhampton College of the University of Richmond. As a student there in 1971, I was searching for a part-time Christmas job when I learned that a Snow Queen position was available at Miller & Rhoads. One of my areas of study at the university was speech and dramatic arts, and I had already had some training and experience in theatre and music. I thought, "What a wonderful opportunity...the perfect Christmas job!"

I reflected on my young childhood dream of being a princess or a queen. I could hardly believe that I would actually be playing the role of the Snow Queen, with the *real Santa* at the famous and beloved Miller & Rhoads downtown store! It was a childhood dream come true!

In the early 1970s, other Snow Queens, Beverly Hargrove Edwards and Carol Ashby Schlichtherle, enjoyed their roles as much as I did, and we alternated job schedules. In those years, customers still enjoyed shopping into the evening hours on weeknights until 9:00 p.m., Saturdays until 6:00 p.m. and Sundays 12:00 p.m. until 5:00 p.m. Santaland was open for visiting children and adults, and the Snow Queens, along with other Santaland staff, worked either the day or night shift.

Many folks thought that the Santaland "cast" was composed of hired performers, but this was not true. With the exception of Santa, all Santaland staff members, including the Snow Queen, the Elf and all others involved with the operation, were either full- or part-time paid employees. For part-time staff, we were paid a minimum wage like most part-time employees. I remember one Christmas season, after working as a Snow Queen for several years, the Human Resources Department offered me a raise in pay of twenty-five cents per hour. They said that it was "somewhat of a special job."

Throughout the years I worked as a Snow Queen, from 1971 until 1991, the minimum-wage pay was not a great issue. For me, it truly never was about the money. But, sadly, I do not believe that

the role of the Snow Queen was considered by the store to be an integral part of the Santaland operation as perhaps it should have been regarded. I know the Snow Queen was not the main draw for the crowds. Children were there to see the *real Santa*, and in later years, in the 1980s, he became known as "legendary Santa." Truly, he was the star of the show, and indeed it was "Santa magic"—a term that became endearing.

But Santa magic was a carefully executed team effort, and it could not have occurred without the Snow Queen. Everyone knew it was unique to visit downtown Richmond's Miller & Rhoads at Christmas, where Santa could call each child by name! Everyone agreed that all other store Santas and corner Santas were merely Santa's "helpers." The Miller & Rhoads Santa Claus was "the real deal," as a parent proclaimed to me during a visit one holiday season.

In my heart, the Snow Queen was the real deal too, and I loved playing the part. Wherever I was, I always seemed to come back to Miller & Rhoads in the role of Snow Queen at Christmas. After graduating from college, I secured a job as a congressional aide in Washington, D.C., and I came home on weekends during the holidays to be a Snow Queen.

A few years later, I moved back to Richmond and became a full-time employee with the Valentine Museum. I requested to take a week of vacation at Christmas, and once again I became a Snow Queen. This was the scenario through the years when working full- or part-time positions elsewhere—I always returned at Christmas to be a Snow Queen.

When I married, and later my husband and I were blessed with our first child, I became a full-time mom, except at Christmas. With the help of my husband and my mother and mother-in-law in baby-sitting roles, and eventually with two sons and going back to work full time, I was able to continue my seasonal job. Christmas just did not seem like Christmas if I was not wearing my dress, donning my tiara, greeting the children and serving as Santa's helper.

Each year I looked forward to reporting to the store early on the day after Thanksgiving, the day then recognized as the kickoff of the retail holiday season. Excitedly, I would enter Miller & Rhoads, eager to embrace *the magic*. I would ride the escalator

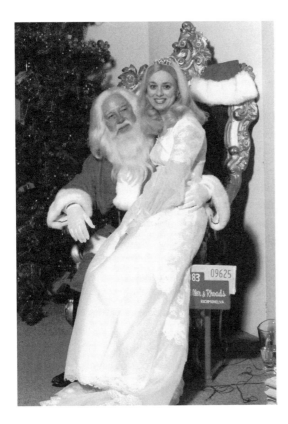

Santa and Snow
Queen Donna
Deekens at M&R,
1983. *Bill and Donna
Deekens Private
Collection.*

to the seventh floor en route to Santaland, admiring the holiday
decor and ambiance as I passed each floor on my ascent. I always
managed to glide past M&R executive Gurney Grant each year,
making his way down the escalator as I made my way up. He
would greet me with a smile and a "Hi, Snow Queen!", and I
would reply, "Merry Christmas, Mr. Grant!" Our cheerful annual
encounter seemed to signal the official beginning of the holiday
season for me at the store.

Although the extra money was helpful at that time of year, it
was the joy and warm feelings about the M&R job that many of
us working in Santaland longed for and fortunately experienced.
Indeed, it was about the children, and it was a role I cherish to this
day. It was an honor and a privilege to be part of history during the
days of Miller & Rhoads.

I never imagined that being a Snow Queen would have such a major impact on my life. Even after the store closed, my experiences remained a lovely influence, and that influence continues today. I still play the Snow Queen as one of my costumed characters for my traveling tea party business, Teapots, Treats & Traditions (www. virginiateaparties.com). Established in 2002, my party business offers a Snow Flake Tea at Christmas, hosted by the Snow Queen, and often I play to little girls who also dream of being a princess or a queen.

For my tea parties, I continued to wear one of the original Snow Queen dresses from the store until just recently. The dress, which has lost its brilliance, now bears a tattered train and torn netting. It was given to me thanks to the efforts of Santaland employee, and my late friend, Ed Collins. It served as my Snow Queen costume when the Santaland operation moved to Thalhimers in 1990, and I wore it one more season during my last year in 1991. Through the years, I appeared in this particular dress more than any of the other dresses in the Snow Queen collection. I often smile when I touch it, and only wish it could somehow come to life and reveal its memories of the wonderful experiences we shared together, greeting thousands of children. Like a good soldier, it just faded away, and I decided to retire it.

Happily, the Christmas spirit continues in other ways reminiscent of those good old days. The Children's Museum of Richmond presents "Legendary Santa" and his helpers each year during the holiday season. Children and their parents still can visit and be photographed with Santa, and also view the museum's fine exhibits during their stay.

Similarly, Santa and I have had the good fortune to be able to team up again for the past few years, playing Santa Teas together at various locations. One tea room and retail gift shop, Feathernesters (www.feathernesters.com), located in North Richmond, has hosted Santa and the Snow Queen during the Christmas season. We have enjoyed greeting children and also adults who delight once more in the experience of being a child. Like our previous appearances at the store, our holiday teas sell out several seatings each year. We are pleased to have the opportunity to greet the enthusiastic crowds

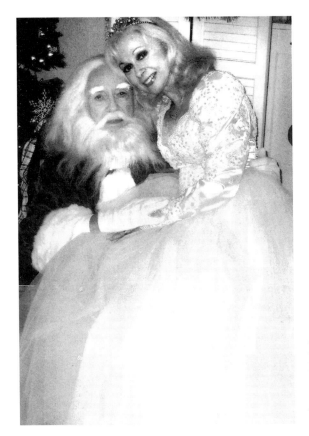

Santa and Snow Queen Donna Deekens at Feathernesters, 2008. *Bill and Donna Deekens Private Collection.*

when we share once more the spirit of giving—the giving of love. In addition, we have had the privilege of visiting ill, home-bound children who might need an extra hug and a comforting smile.

I know Santa agrees with me that during our Christmas visits now, just as it was at Miller & Rhoads, we are the recipients of more joy and goodwill than we can ever return. The simple truth is that *we* are the ones who have been profoundly blessed.

And so, the tradition continues in my heart and in the hearts of all those who still *believe* and *remember*...

BCD/09

The *Real Santa*

Miller & Rhoads in downtown Richmond was the home of the *real Santa* at Christmas. If you were from Richmond, you probably knew of our famous Santa; however, you may have taken it for granted that we truly had a "gem" in our midst.

Nevertheless, stories about our wonderful Santa spread far and wide. His reputation had grown steadily through the years. Folks from all over the eastern seaboard and other parts of the United States visited the store just to share a wink, a hug and a reassurance that "Yes, Virginia, there is a Santa Claus!"[2] Families traveled from Florida, Georgia, South Carolina, North Carolina, West Virginia, Maryland, Pennsylvania, New Jersey, Louisiana, California, Texas and Washington, D.C., to visit the store.[3] Children and their parents were eager to make the visit, seeking what they perceived that this particular Santa personified: the true spirit of love, human kindness and the giving heart.

The story of the Miller & Rhoads Santa began in the 1930s, when the role was initially played by a man named Green. He was from a rural area and had to be sent to the beauty parlor to be cleaned up for his first appearance. (He was the only Santa with a real beard.) A few years later, Timothy L. Light appeared as Santa Claus until ill health forced his retirement.[4]

The next Santa was perhaps the most famous, for he set the precedent for the tradition of what the "real Santa" and later

"legendary Santa" would come to mean. He was William Strother, a Hollywood stuntman often referred to as "the Human Fly." A native of North Carolina, Strother and his wife relocated to Petersburg, Virginia, in the early 1930s. In 1942, he answered an advertisement in a Richmond newspaper for a Santa Claus at Miller & Rhoads.[5]

According to an article entitled "The World's Highest Paid Santa Claus," written by the Richmond-based author and historian Clifford Dowdey in the December 22, 1951 issue of the *Saturday Evening Post*, Strother was interviewed by the store's executives. Dowdey said:

> *Bill outlined to them the accumulated ideas which would communicate to others the simple and profound belief in the need of rising above selfishness through thinking of others. He was sincerely convinced that this age-old message could best be conveyed at Christmas and to children when they were most receptive.*

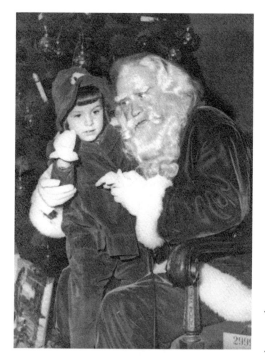

Santa listens intently to Judith Strother Jones during her visit to Miller & Rhoads, 1948. *Ron and Judy Jones Private Collection.*

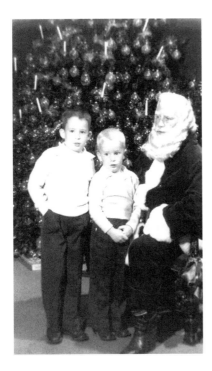

Andy (left) and Bill Deekens visit with Santa, 1956. *Dr. and Mrs. S. Andrews Deekens Private Collection.*

Though no actor, his original notion, once he took the job, had been to make a good show of it. When he first saw the expectant faces of the children, he was profoundly moved. He said, "They won my heart and I forgot all about acting. I put everything of myself into what I was doing, and each child became as precious to me as if he were my own flesh and blood.[6]

This Santa's ideals melded with the store's commitment to children, especially during the holiday season. M&R embraced Bill Strother's vision. His ideas of a Santaland were endorsed by the store's executives, and these ideas were eventually patented. This wonderland was created in the Old Dominion Room on the seventh floor. On the stage, a fireplace was introduced where Santa could be seen coming down the chimney, "to appear there to the children as Santa Claus had traditionally appeared in their imaginations."[7]

He arrived at Santaland looking the part. He wore a beautiful red suit made of French velvet imported from Lyon. His white

collar and cuffs were made of rabbit fur. Hollywood's Max Factor created his wigs and beard.[8] "His blue eyes [were] merry beneath frosty eyebrows; and above his snowy beard, the ruddy glow of his cheeks looks as if he had just finished a winter night's ride in an open sleigh."[9] But the most important characteristic of this Santa Claus was one simple fact: *he knew each child's name.*

Indeed, this is the Santa I imagined and first visited as a child in 1956. This is the Santa with whom I fell in love. He greeted me with sincerity and a gentle, genuine nature that suggested warmth, love and charity. There was no doubt in my heart or in the hearts of all children that yes, he was the real Santa.

Arthur "Chuck" Hood followed in the tradition of the true spirit of the season, beginning in 1956. He was fitted with a red velvet suit and professional makeup from Bob Kelly of New York.[10]

"No expenses were spared," said Carolyn Hood Drudge, Santa Chuck's daughter. "I remember hearing the story of Daddy standing on a piece of brown paper and they drew a line around each of his feet. They sent it out to New York or wherever, and those beautiful Italian boots were custom made just for him."

"He loved being Santa," said Frances Hood of her late husband. "He was so excited when Miller & Rhoads asked him to work the evening shift in 1956 when the store began staying open in the evening. Mr. Strother was working a long day and could not handle evening hours, too. Chuck was told he resembled Mr. Strother in size and facial features—especially his sharp nose."[11]

On occasion, Santa would venture out of the store to work his magic. Such was the case with Santa Chuck and a little boy, Jimmy McFarland. According to Mrs. Hood, Jimmy was about six years old and lived in Bowling Green, Virginia. He and his family came every year to visit Santa until 1986, when Jimmy was undergoing treatment for a brain tumor.

"Santa traveled to Jimmy's home in Bowling Green to visit the little fellow, as he was not able to make the trip," Mrs. Hood said. "Jimmy made a Christmas card thanking Santa for his special visit. It was all very touching."

The Santa tradition continued. With transportation opportunities improving due to more reliable automobiles, accessible train

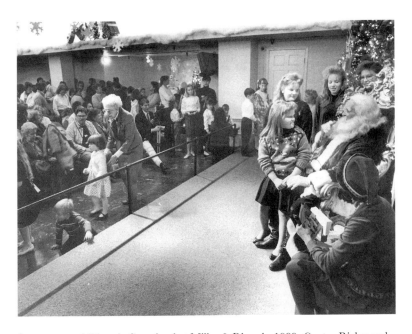

Santa greets children in Santaland at Miller & Rhoads, 1989. *Courtesy* Richmond Times-Dispatch.

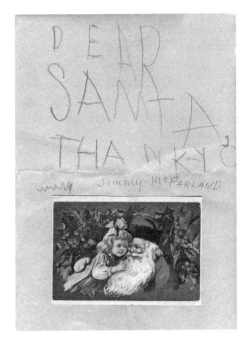

"Thank you Santa" Christmas card, made by Jimmy McFarland for Santa, 1986. *Frances M. Hood Private Collection.*

travel and growing air travel, visiting Santa in Richmond at Christmastime was not just an option for many families. It became an annual observance.

Santa Chuck dedicated many years to children at Miller & Rhoads, and he was committed to his role. For Christmas 1990, he moved across the street with the Santaland operation to Thalhimers, and then onto other Santaland locations when that retailer shut its doors.

"Santa Chuck was so special," said Brenda Marshall Thompson, who was a Snow Queen from 1986 to 1989. "He gave me my orientation about being a Snow Queen, a job which I came to love. He helped build the Santaland stage and the backstage area, and Mrs. Hood devoted her sewing talents, making Santa suits in the 1980s. My husband's dry cleaning business cleaned the Santa outfits and the Snow Queen dresses. We were all involved in some aspect of the operation until the store closed."[12]

Beverly Hargrove Edwards, a Snow Queen from 1967 until 1980, agreed that working with Santa was a very special job, and great fun. Mrs. Edwards said that she learned of the Snow Queen position from her sister, Carolyn, who was employed at the store.[13]

"I had finished VCU and was teaching kindergarten, but I applied for a part-time Snow Queen position at Christmas," said Mrs. Edwards. "It was exciting to be fitted for our dresses in the store's bridal department, and I simply loved every minute of the job."

Mrs. Edwards recalled the time she was leaving the store and stepped down off the curb and broke her right foot. "I had to wear an orthopedic boot," she said. "I could still work, as the long dress covered the boot, but I had a slight hobble when I walked. Santa told everyone that Rudolph had stepped on my foot," she laughed.

"I used to chuckle when Santa Chuck and I had experienced a really busy day," she added. "He had a great sense of humor. At the end of the day, we would go backstage, breathe a big sigh and he would shout, 'Wee…Doggie!'"

As a Snow Queen for many years at M&R, I too enjoyed working with Santa Chuck both in the store and off-site. He loved being Santa and appreciated the role of the Snow Queen. He hosted a luncheon for his thirtieth anniversary in 1986, commemorating his

years as Santa at the store. At that event, he invited many of the ladies who had worked with him, including Hattie Moore Garrison in the 1950s and early 1960s. His thank-you gifts to his Snow Queens at Christmas would often be accompanied with a handwritten note saying, "Thanks for the memories—Santa C." I still cherish several Christmas tree ornaments that were gifts from Santa Chuck; they adorn my tree each season. He was loved and is greatly missed.

Beginning in the 1960s, although there was officially one Santa at a time, there were actually up to three because of the number of hours involved and the number of children to meet.[14]

Hansford Rowe, a Richmond actor, brought his talents and joy as Santa in the 1960s. His younger brother, Dan Rowe, began in 1966. He stayed through the store's closing and has continued as Santa at all subsequent Santaland locations. Now in his eighties, Santa Dan still delights in his role and relishes memories of encounters with children across generations.[15] Special visits are cherished by Santa Dan. One visit he holds dear is that of a baby girl, Kristin Hardwick, who came to see Santa at M&R in 1988. Ms. Hardwick always wanted to be a Snow Queen. Her wish came true at Santaland at the Children's Museum of Richmond in 2004. She wrote:

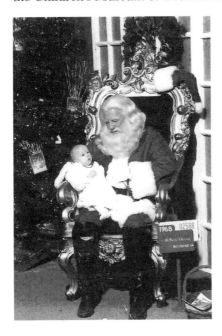

Baby Kristin Hardwick and Santa at Miller & Rhoads, 1988. Kristin later became a Snow Queen at the Children's Museum. *Babbitt Family Private Collection.*

*Santa Dan was always so sweet and has always been the Real
Santa to me! The Snow Queen was beautiful. She was graceful,
elegant and classy…everything I wanted to be. She represented the
beauty of what I as a little girl admired and cherished. Believing
that she could bring the most beautiful snow and understand the
uniqueness of a single snowflake created my desire to someday
become the Snow Queen. Many years later in 2004, the excitement
of Santa continued. My first day of walking out on the stage—it
was like deep down I believed that for minute I could make little
girls' dreams come true![16]*

As a Snow Queen to Santa Dan, I was greatly impressed by his
enthusiasm and his professional showmanship. It was always a treat
for me and for any of the Snow Queens to work with him. His love
of the children and devotion to carrying on the tradition of Santa
magic was and continues to be paramount to him. I admired his kindness and patience with the children, and his amazing memory. When recalling visits to the store at Christmas, for many folks, Santa Dan comes to mind. He has been and continues to be loved and adored by so many admirers. Happily, he continues the tradition at Santaland at the Children's Museum.

Santa Dan has been "in the chair" for decades, and visitors still flock to see him. One of his greatest "fans," Harriett Heath of Portsmouth, Virginia, clings to her belief in Santa and has made it an integral part

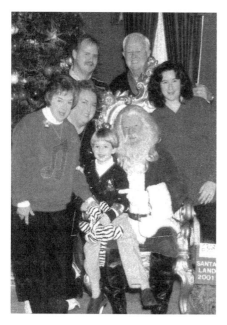

Three generations of the Heath/Warren family visit Santaland, 2001. James Warren talks with Santa. *Harriett and Ed Heath Private Collection.*

of her life. She visited Miller & Rhoads as a young girl in the early 1940s, and her family photographs tell her story of three generations, continuing the tradition at the Children's Museum today.[17]

As a choral teacher in the Portsmouth public schools, Mrs. Heath taught at Manor High School and brought seven of her students to the store to see Santa in 1983. "I kept bringing people from Tidewater up to Richmond to Miller & Rhoads, and some of my students commented, 'We are so tired of you talking about the real Santa and taking other people to Richmond, so why don't you take us?' they asked. So, I did!" said Mrs. Heath.

"When we were in the Tea Room, I spoke to Eddie Weaver whom I had met years before, and told him I had some students with me," she said. "The next thing I knew, when Santa came into the Tea Room, he called all the students by their names! They were dumbfounded, and it was so much fun to see high school students act like little excited kids again!"

In 1980, Charles Nuckols began creating Santa magic at Miller & Rhoads. He continued until the closing of the store and also moved to Thalhimers and then other Santaland locations. "I loved every minute of it," he smiled. "The red suit made me happier!"[18]

In the role, Santa Charlie would use his knowledge of sign language with children who might recognize it. When I worked as his Snow Queen, I marveled at how he could pick out a child in the crowd and use sign language to make his connection.

"The language is international, and I would sign 'I love you' or 'I love you with a hug,'" he said as he demonstrated. "One of the things I have historically done in a parade is the 'signed Santa wave,' displayed with a gloved hand, and a firm wave 'hello,'" he said. "If I have received one response back, I felt like I led a successful parade. Most of the time I received a response. Then right away, I'd give the sign for 'That's all I know!'"

Santa Charlie enjoyed starring in the "Santa Party" on Saturday afternoons in the Tea Room. I accompanied him as his Snow Queen for many of those fun events, which included music by Eddie Weaver on the organ and Charlie Wakefield on the accordion. Theatre IV actors, headed by Bruce Miller and Phil Whiteway, would join us onstage.

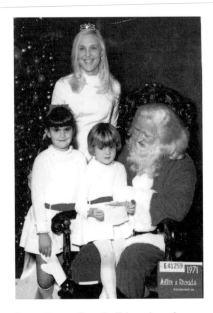

Snow Queen Beverly Edwards and Santa visit with Tracey (left) and Janet Pollard, 1971. Janet became an Elf and a Snow Queen. *Janet Pritchett Private Collection.*

Janet Pollard Pritchett also was a Snow Queen for some of the Saturday parties. Mrs. Pritchett had worked as an Elf for several years in the late 1980s. She continued the role before taking on the Snow Queen position and made the transition to Thalhimers in the early 1990s. She explained how she was inspired as a child visiting her kindergarten teacher, Beverly Edwards, who was a Snow Queen. "I knew I wanted to be an Elf or a Snow Queen, and I got to do both. I even worked with Santa Chuck in the late 1980s whom I had visited when I was a child. It was wonderful!" Mrs. Pritchett said.[19]

"I remember how sweet Santa Charlie was when I first did a Santa Party with him," she recalled. "Theatre IV characters were behind the Tea Room stage where Santa and I waited until we would make our entrance for the finale. I remember that the backstage space was extremely small and tight. Santa warned me that the Theatre IV players had several quick costume changes and for me not to be shocked, as the actors had little time to worry about modesty," she laughed. "I appreciated his 'heads-up' advice!"

Snow Queen Brenda Thompson, who worked nights with Santa Charlie, said that she thoroughly enjoyed watching his dedication. "For me," she said, "it was a pleasure to witness his commitment and love of the children."

As a Snow Queen to Santa Charlie, I too witnessed this same commitment to the children. He possessed a true sense and awareness of childlike wonder and innocence. Like Father

Flanagan of Boys Town fame, Santa Charlie always seemed to have the optimistic view that all children indeed are good deep inside. He believes that every child can be reached simply with love, respect and patience. In many ways, this is the essence of the real Santa, and this is Santa Charlie. He is loved by so many admirers—children and adults alike.

I treasure the years I worked with him at Santaland, and we continue to enjoy visiting together with children on occasion at Christmas. "The magic" is still very real to Santa Charlie and to me, and, of course, to anyone…if you only believe.

This Santa's love of the children was evident to two young parents and their newborn twins during a visit with Santa Charlie one memorable year. According to him, it was one of his most touching moments at Miller & Rhoads:

> One morning I arrived at the store early and I was dressing. Whoever was minding the store let me in and as I was getting ready, the Santaland folks who were already there early came to me and said, "How near are you ready?" I said, "I'm nearly ready completely. What are you talking about?"
>
> The Santaland gal on duty said one man and his wife are out here and they didn't know what time Santa went to work. They had twin babies—a little boy and a little girl—and they wanted to make sure they got their pictures taken with Santa. The store gal said, with tears in her eyes, "They want to make sure they can see Santa because one of them is going to die, and they're not sure which one it is." I said, "Well, what are we doing?" She said, "How soon can you see them?" and I replied, "I'll be ready in four minutes," as I just needed to put on my coat and gloves. So, I did that and I said, "I'm not even going to come down the chimney; I'll just come out the door."
>
> So, I opened the door and made my entrance declaring "Merry Christmas!" I thanked them for coming by to see Santa and I told them anytime was the right time to visit Santa. I told them I was just taking care of the reindeer. The couple were young—he looked like he was about nineteen and she was about eighteen. Dad was holding one infant and Mom was holding

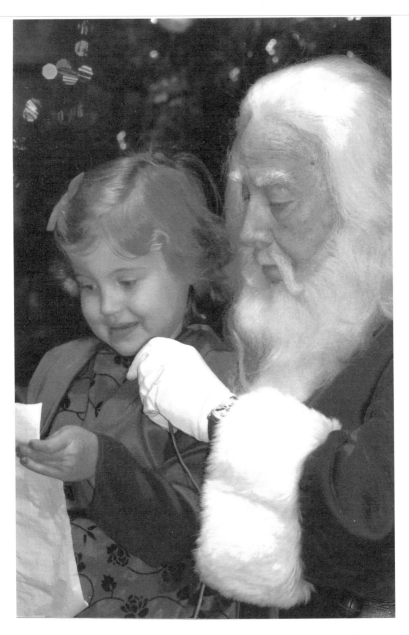

A little visitor to Miller & Rhoads checks her wish list with Santa, 1989. *Santa Charlie Private Collection.*

the other. I don't recall how old the babies were, but they were definitely premature.

The couple said, "Santa, these are our new babies and we don't know how many Christmases we've got with them. We wondered if we could get their picture taken with you." I said, "My photographer is not here yet, but do you have a camera?" They said yes, so I sat in that big chair, and I said, "Put those babies in my arms here where they belong!" and the babies and I had a long talk. The parents were so appreciative.[20]

Santa Charlie experienced other moments that "pulled at the heartstrings" while making special appearances at off-site attractions and special events. From 1987 to 2000, he appeared at the Children's Hospital with the Snow Queen and Elf.

"It was always a wonderful event for the 175 children we visited," said Santa Charlie. "WRVA's Tim Timberlake was our MC and all the food and toys were donated every year, thanks to the efforts of longtime M&R employee Milton Burke. Everyone opened up their hearts to the children."

Santa Charlie also provided Christmas cheer for folks at other facilities that welcomed his goodwill, among them the Virginia Home for Adults. Often, Milton Burke accompanied him and served as "Santa's chauffeur." The Medical College Pediatric Unit was another "must-visit" on Santa's list.

Santa Cullen Johnson knew how to connect with the children and everyone who came to visit Santaland. He enjoyed his role as Santa Claus at M&R in the late 1980s, and then at Thalhimers and other Santaland locations in the early 1990s.

"He loved people, especially children, so being Santa Claus was very satisfying to him," said Cullen Johnson Jr., his son, who lives in New York City, of his late father. "He had an animated personality and expressive eyes, which helped him portray his character genuinely." He was such a giving individual, and he truly put all his energies into being Santa."[21]

As a Snow Queen, I had the privilege of working with Santa Cullen on several occasions, and I recall how delightful he was both on and off the stage. His booming but warm, velvety voice was an

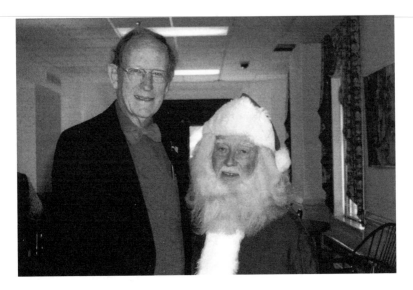

Milton Burke, longtime M&R employee, and Santa at the Virginia Home for Adults. *Santa Charlie Private Collection.*

automatic draw for children. His kindness and giving nature were apparent. I thought he was a natural for the role.

Cullen Johnson Jr. confirmed that Tea Room organist Eddie Weaver had suggested to Johnson Sr. to look into playing the Santa role. "Eddie encouraged Dad, as Miller & Rhoads was seeking another 'Jolly Old Elf' to help out during especially busy hours," said Johnson.

"Dad and Eddie had been friends for years in the entertainment industry, first becoming acquainted when Dad was doing radio," Johnson explained. "Eddie was a great inspiration to him and thought Dad would make a perfect Santa, which he did!" said Johnson.

"Dad had a real knack to key into each child who visited with him," he noted. "There were times when children didn't know what to say and Dad would fill in the blanks so well it was as if that child really did have a wish request!"

Santa Cullen's daughter, Bobbie Kay Wash, agreed that her father was in his element as Santa. "I remember him telling us cute stories about the children, and one involved a little boy who had received his Rudolph cake from Santa in the Tea Room," said Mrs.

Wash. "Apparently, there were so many children huddled around Santa, he didn't realize he had given one child two pieces of cake," she continued. She added that Santa explained that he could hear the youngster running back to his table shouting, "Oh, my God, I got *two* pieces!"[22]

Mrs. Wash recalled another humorous incident when Santa Cullen made an appearance at a Christmas party at a private club. She said that he headed out to the parking lot to leave. As he approached his car, he turned around and was surprised to see a small group of children following him. "They wanted Santa to show them his reindeer and sleigh," said Mrs. Wash. "I'm not so sure how he got out of that one, but no doubt he did it convincingly and remained 'in character!'"

Santa Cullen's youngest son, Ritchie Johnson, also thought that his dad relished the role of the legendary Santa. "It was especially meaningful for him to play Santa with his own grandchildren," said Johnson. "My daughter, Sarah—his granddaughter—has wonderful memories of her visit with him in 1992. He was the real Santa to her."[23]

Santa makes adjustments in preparation to visit with children in Santaland, 1988. *Ritchie and Donna Johnson Private Collection.*

Whether choosing to refer to the lovable icon in the red suit as the real Santa or the legendary Santa, you could find him for decades at Miller & Rhoads. During your visit, you could be certain that this Santa would be familiar with all the latest and greatest toys of the day. This Santa would be happy to be the recipient of just about anything children might offer him during their visits—letters, wish lists, pacifiers, tree ornaments, candy and even a quart of fresh oysters from Virginia's Eastern Shore.[24]

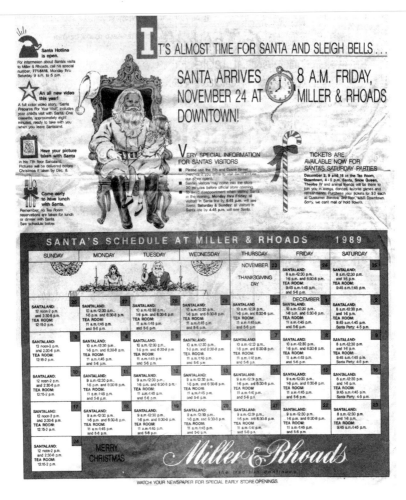

Santa's schedule at Miller & Rhoads, 1989. *Courtesy* Richmond Times-Dispatch, *Bill and Donna Deekens Private Collection.*

Usually, he would place these treasures inside his boot or in a basket by his chair.

Sometimes children would bring Santa a key to their house if they did not have a chimney with a fireplace for him to enter their home. If this was the case, Santa would reassure the children that he would be coming by to see them, even if a chimney was not available.

He would also relieve children's worries, explaining he would find them wherever they might be visiting at Christmas if not at home—perhaps Grandma's house. And he would kindly ask the children if they might leave him some milk and cookies (chocolate chip being his favorite) by their tree, for surely he would be "hungry and thirsty when he arrived." Additionally, if they had a carrot on hand, Rudolph would be most appreciative to be remembered as well.

It was obvious to everyone who was privileged to visit with Santa, or anyone who was fortunate enough to work with him, that he absolutely reveled in the role. His energy was boundless and his face could light up a room. He was warm, electrifying and, at times, even mesmerizing. He adored the children. But more importantly, the children and even adults who visited Santa adored him and revealed to him not only their wishes, but very often the secrets of their hearts.

This Santa calmly offered advice from "the chair." He suggested that brothers and sisters "stop their fussing and fighting" and "please remember to help out around the house." And he asked the little ones "to remember the children who are less fortunate."

This Santa "promised to do the best he could, and he reminded the children to do the best they could."[25] His presence was so touching, so captivating.

The real Santa delved deep into the soul and brought out in everyone the very best of the power of the human spirit. His persona portrayed goodness, compassion and charity, and he offered to all what he believed to be life's most precious gift—love.

And, to everyone's amazement and delight, what is most remembered and cherished...*he knew your name!*

"Time to Check on the Reindeer!"

Each morning during the holiday season, beginning the day after Thanksgiving, Santa made his official entrance to greet children and adults alike in Santaland. Visitors would excitedly ride the elevator to the seventh floor from the first-floor lobby (the last elevator on the right was known as the "Santaland Express"), which a mother gleefully described to me on one occasion as "the flight to heaven!"

Others who ventured to Santaland elected to ride the escalators, winding up to the top, their excitement building with each moving step from one floor to another. Such emotion emanated from everyone who flocked each Christmas to make the pilgrimage to visit the *real Santa*.

Most people realized that they had just begun their journey once they made it to their lofty destination. Often, the line to get into Santaland was a two- to three-hour wait, winding down the hall past the elevators. Chatter and laughter could be heard from those who waited in anticipation of their impending visit. Of course, eventually there were cries from tired children as well. Overall, those who waited their turn were patient and good-natured. In the familiar fantasyland setting, most people felt very light-hearted about lining up to visit with Santa, the Snow Queen and the Elf. Visitors would conclude that it was definitely worth the wait.

Those who were fortunate enough to arrive in the morning before Santa made his appearance would try to situate themselves for the

best view of the mantel and fireplace located on the stage. Parents wanted to allow their children the best opportunity to witness Santa coming down the chimney.

One of the Santaland staff who was an official greeter would command attention from the audience. In my beginning years of playing the Snow Queen in the early 1970s, the gathered crowd was often welcomed by Ken Allen, a Miller & Rhoads executive, who ran the Santaland operation in those days. Allen had a sharp eye and keen ear for entertainment, having organized USO shows during World War II. He made the workings of Santaland and Santa's and the Snow Queen's visits to the Tea Room run like professional performances. I remember him being somewhat of a taskmaster, but everyone respected his flair for showmanship.

The store remained open in the evenings on weeknights until 9:00 p.m., and Santa and his staff would be on duty. Those visitors in line could enjoy the treat of seeing Santa come down the chimney. Many of those waiting to visit with him at this time often dined with him in the Tea Room for the evening meal prior to his nightly appearance.

As one of the Santaland staff working the "night shift," Charlie Harper would come from his job as a salesman and owner of Harper Hardware Company, a downtown Richmond institution since 1898. He would place a Santa hat on his head before stepping onto the stage to greet the anxious crowd. Often during their respective shifts, both Harper and Allen would lead Christmas singalong songs with the audience prior to Santa's entrance.

Allen particularly enjoyed being an entertainer and would "ham up" his prelude to Santa's introduction. A round and jolly gentleman himself, he would don a Santa hat and step onto the Santaland stage, booming, "Good morning!"

"Good morning!" the crowd would reply.

Often, Allen would follow that response with, "Well, tell me now. Have you *all* been *good?*"

"Yes!" would be the loud reply.

"I don't think Santa can hear you from the roof!" Allen would say, pointing upward. "You know, he's up on the roof, checking on the reindeer, so answer as loudly as you can! Have you *all* been *good?*" he would ask more emphatically.

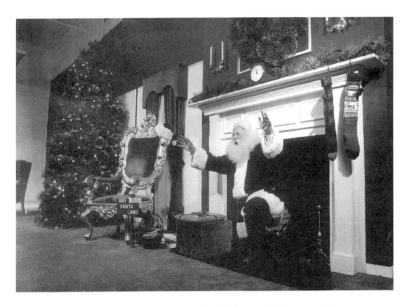

Santa arrives down the chimney in Santaland. *Courtesy* Richmond Times-Dispatch.

"Yes!" would be the squeals permeating the room.

"Good! Well now…watch the fireplace," he would say, pointing to it, and then with a twinkle he would add, "and listen for sleigh bells!"

A hush would come over the crowd, and all eyes would be fixed on the Santaland stage, festively decorated with Santa's majestic chair and the Snow Queen's elegant-looking chair. These "thrones" were appropriately separated by a beautifully decorated Christmas tree, with shiny wrapped presents placed invitingly underneath the tree's branches.

All eyes were on the fireplace, complete with "stockings hung with care" from the mantelpiece. The silence of the moment would be broken only by the merry sound of sleigh bells. Then, first one boot could be seen descending from the chimney, and then another boot. As boots dangled, "oohs" and "aahs" from the audience could be heard, and both boots would touch the floor of the inner hearth. Santa, bearing his familiar hat, finally would pop out from beneath the fireplace, carefully clearing the mantelpiece so as not to bump his head.

"Well, hello, Santa's babies!" This was the greeting everyone eagerly awaited. Children and adults, and indeed all young at heart, would reciprocate and welcome Santa with wild applause and shouts of joy.

Santa continued with his greeting:

> *I'm so glad to see all of you! I've just been up on the roof, checking on the reindeer, and they're all all right. They're stamping their feet, and snorting* [while mimicking the reindeer's actions]. *They just can't wait for Christmas to get here!*
>
> *And I'll call them by name: "On Dasher, on Dancer, on Prancer and Vixen; on Comet, on Cupid, on Donder and Blitzen...and you too, Rudolph!" And away we'll fly...right over to your house! Have you been thinking about what it is you want for Christmas?*

"Yes!" would be the ecstatic reply.

"Well all right, let me get my lovely Snow Queen and little Elf out here, and we will find out just what it is you would like ole' Santa to bring you! Come on out Snow Queen!" he would call.

On cue, I made my entrance as elegantly as possible, exiting from the door located adjacent to the fireplace. Smiling and waving to the wide-eyed audience, I would embrace the moment. Holding the skirt of my white dress—the appropriate attire for all Snow Queens—and nodding to Santa, I would say, "Hello, Santa!"

"Hello, Snow Queen! My, you look lovely today!"

"Thank you, Santa," I would reply.

"See how she smiles and everything! Ole' Santa loves smiles. May I see some of your smiles?" he would ask.

Shining smiles emanated from everyone and seemed to cast an extraordinary aura on the already glowing room. The Elf dutifully followed behind me. (Young high school and college girls were hired to be elves during my years as the Snow Queen. Often, some of the girls "graduated" to the Snow Queen role.) "The mischievous little Elf," as Santa liked to call her, would skip out in a Christmas red and green outfit, waving ecstatically to the audience. A pointed hat and slippers completed her impish costume.

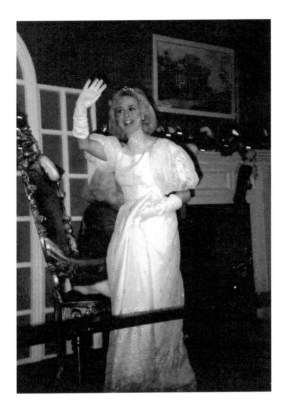

Snow Queen Donna Deekens makes her entrance in Santaland at Miller & Rhoads, 1988. *Cathy and Rob Savage Private Collection.*

"Hello, little Elf!" Santa would acknowledge his other helper.

"Hello, Santa," Elf would respond.

As Snow Queen, I would go directly across the stage to my chair, sit down and immediately straighten out my dress, with the Elf's assistance. Santa would remove his hat and lay it strategically on the back of his chair. Then he would position himself comfortably, looking regal in his high-backed throne. Again, the Elf would greet Santa and perch herself on the stool next to him. Then she would present him with a hand mirror and comb. While holding the mirror, Santa would look at himself and run the comb through his long, white beard.

"How's that, little Elf?" he would inquire, admiring his image.

"Fine, Santa!" was her reply.

While the audience would be entertained watching Santa groom himself, I would discreetly settle into my chair. It was all

very proper—the carefully planned "fashion tie-in," my contact with Santa, was hidden from view of the audience. At that moment, Santa could hear everything I would say by way of this "established access" to the Snow Queen. Thus, the stage was set. It was time for Santa and the Snow Queen to work their wonders to make "Santa magic." The Snow Queen would talk with each child first. Santa would listen for the child's name, turn and acknowledge the waiting child or children and call each by his or her first name. Surely, knowing each child's name, he must be the *real Santa*!

"Hi," I would say, greeting the first child of the day. "What's your name?"

"Scott," the neatly dressed little boy would reply coyly.

"Okay, now wait right here Scott, and Santa will see you in a minute!" I would say, repeating the name "Scott" as articulately as I could. While I was conversing with young Scott, Santa would be busy finishing up with his grooming and waving to the other children. But the most important thing he was doing at that point was making certain that he heard the first name and heard it communicated correctly. If it was a group of children, all names had to be acknowledged and sometimes repeated discreetly. It was a routine, but it had to run like clockwork, and it had to exude believability.

I distinctly remember one year when a crowded Santaland, on an extremely busy Saturday morning, produced an even more excitable than usual audience. The line to get into Santland had been forming for some time, as Santaland opened an hour earlier, at 8:00 a.m. instead of 9:00 a.m. By the time Santa, the Snow Queen and the Elf came on, elation roared from the anxious crowd, and there was no doubt a sigh of relief from all in attendance that the show had finally begun.

Santa came down the chimney and went through his usual routine. He greeted the children and adults, and then introduced me as his Snow Queen and also introduced the Elf. We made our entrances when cued, and I recall being "wired," both literally and figuratively, for this seemed to be such a great group to play to to begin the day.

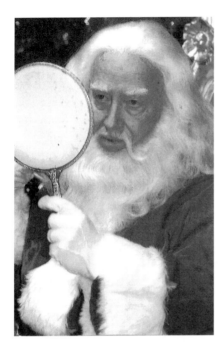

Left: Santa grooms himself on the Santaland stage in preparation to visit the children, 1989. *Santa Charlie Private Collection.*

Below: Scott Savage visits with Snow Queen Donna Deekens before seeing Santa, 1988. *Cathy and Rob Savage Private Collection.*

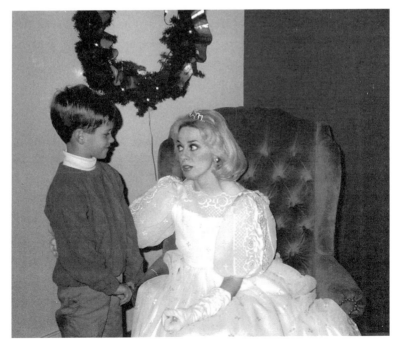

While Santa was busy going through the grooming part of his routine, I greeted the first child in line, probably about three years old, who seemed nervous and somewhat hesitant to leave his mother's side. I talked with him, and his mother helped him tell me his name. He was Sam, and indeed, he was excited to tell Santa what he wanted for Christmas. I said, "Wait right here, Sam, and Santa will be ready for you in a minute."

Santa looked over toward us and called out, "Hi, Sam! Come on over and see ole' Santa! Yes, that's right…right over here!" he said, as he lovingly stretched out his hand to Sam. "Come and hop right here on my knee."

"Now Mom," he added, "move right over there," motioning to Sam's mother to move out of the line of the camera's view so that the photographer could take Santa and Sam's picture. (Photographs were automatically taken, even if they were not purchased.) Santa would say, "Look right here and let's have a big smile." The camera, located on the floor just below the stage, snapped the picture. Often, parents would take pictures with their own equipment, too, evidenced by the "click, click, click" resonating through the room.

"Good," Santa grinned. "Now, Sam, tell me what it is you would like for Christmas."

This was my cue to say the next child's name. I had already learned what it was.

"Now wait right here, Benjamin, and Santa will see you in just a minute," I promptly said on cue.

Sam sat on Santa's lap and enthusiastically relayed his memorized list. Santa actually was listening intently for that next name—"Benjamin"—and really not committing to memory the items on little Sam's list.

"Well now, Sam, that's a pretty good list, isn't it?" Santa said. "And I bet you like surprises, too, don't you?" he asked.

Sam nodded in agreement.

Santa continued and said, "Now, Sam, you be good and I'll be coming by on Christmas Eve to put some nice goodies under your tree…and remember, ole' Santa loves you! All right, Doll Baby, Merry Christmas!" And with that confident farewell, Santa carefully

helped Sam down from his lap and placed him on the stage floor. The Elf presented him with a Santaland coloring book and a candy cane, and the satisfied little fellow ran down the ramp to meet his waiting mother. Both Sam and Mom were all smiles.

I had already begun carrying on a conversation with Benjamin, asking him if he had been good this year and if he was ready for Christmas. I was expecting Santa to call Benjamin by his name, giving that personal greeting that all children came to expect from the real Santa.

But surprisingly, Santa stood up and said, "Boys and girls, moms and dads, Santa has to take a quick break and go up on the roof and check on the reindeer. I understand there is a little problem which I must attend to."

I looked at Santa, a bit puzzled, for we had seen only one little boy, and Santa was "checking on the reindeer" already? Usually we would see children for at least two hours before we would take a break. Sometimes we would go three hours before taking a break, especially if the line was extremely long and the room crowded with an excited group, as was the situation this Saturday morning.

Whenever Santa, the Snow Queen and the Elf had to "check on the reindeer," there would be disappointing looks from children and adults, and even some angry glances from weary moms and dads. Sometimes echoes of "Oh no!" could be heard through the room. That was particularly the case this time, since only one child had visited with Santa.

But I knew something had happened and there had to be a good reason that Santa had precipitously announced that we were "checking on the reindeer," and so soon after beginning our day. We left Santaland through "the magic door" located behind the Snow Queen's chair and made our way backstage. Santa whispered to me and to a surprised and somewhat frenzied Ken Allen, who waited behind the scenes, "Little Sam was so excited to see me, he peed on me, and I have to change my pants!"

Such an accident was the reason why Santa had three outfits, in the event that he would be wet on or thrown up on unexpectedly. For Santa, it happened quite often, and it was all in a day's work. I

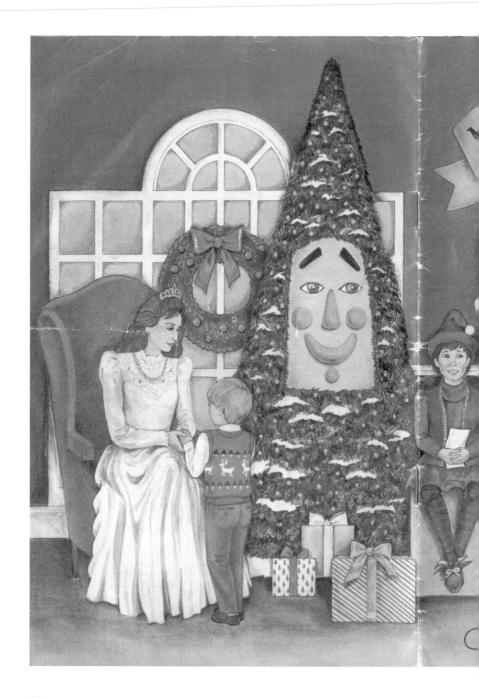

Coloring book presented to children who visited Santaland at Miller & Rhoads, 1989. *Bill and Donna Deekens Private Collection.*

Benjamin Emerson was less than happy during his visit with Santa, 1986. *Nancy and Ben Emerson Private Collection.*

Santa visits with M&R employees including Charlie Harper (right) at the Santaland checkout counter, 1977. *Beverly Edwards Private Collection.*

don't remember any child ever wetting on me or throwing up on me, but normally I did not have children crawling up in my lap.

While we were backstage, I reminded Santa that the next child in line was Benjamin. Santa changed his pants as quickly as he could, and the crowd's patience was rewarded with his coming down the chimney once more and going through his routine and introductions a second time. Everyone returned to a state of excitement and glee. Santa turned to the patiently waiting little boy and motioned, "Hello, Benjamin!" reinforcing the magic that Santa *does* know each child by name. Little Benjamin was ready for his special visit with Santa, who greeted him with a smile, a hug and also a dry pair of pants!

It's All About the Children

One expression I have heard all my life through the years is "Christmas is for children." In my opinion, nowhere was that beautiful quote better represented than at the Miller & Rhoads downtown Richmond department store during the Christmas holiday season.

Children came to the store in droves. They came with their parents, grandparents, aunts and uncles, cousins and friends, all seeking the *real Santa*. Some children visited only one time, but most made a yearly pilgrimage. It was a tradition that began at Miller & Rhoads in 1934 and continued in the same location until the final Christmas season in 1989. Thousands of children visited Santaland in those years, and many generations of families made that special time a family tradition that continued year after year. It was an extraordinary event sought after by all who desired to be recipients of *the magic*.

In the days before the upscale suburban malls, people traveled downtown to be part of the Christmas experience. They would stroll the colorfully lit streets and gaze at the exquisitely decorated store windows. Inside the grand department store, visitors could dine in the Tea Room; chat with the talking tree, "Bruce the Spruce"; make purchases chosen by the children in the Fawn Shop; and, of course, visit Santaland, with Santa, the Snow Queen and the Elf.

But the dearest and most important feature apparent at Miller & Rhoads during that special time of year was simply *the children*.

Everyone wanted to watch the children and observe their wide-eyed innocence and ability to believe. The children shared their love, smiles and sometimes tears, and adults wanted to be transformed to that long-ago and faraway place, even for only an instant, to experience once again the whimsy and wonder of childhood. As Santa would say, "It's all about the children!" Indeed, it was, and snatching a glance or a moment of that "Peter Pan" bliss of never growing up was contagious and savored by all.

During my many years working as a Snow Queen (including two Christmas seasons at Santaland at Thalhimers after M&R closed in 1990), I was fortunate to be in a position to closely observe the faces of the children who visited and the adults who accompanied them. It was obvious that they were on a mission. That mission was to visit the jolly old elf, Santa himself, and see all the wonders of Christmas that Miller & Rhoads had to offer to celebrate the season.

The heightened expectations from those visits, as well as the visits themselves, provided many interesting stories. As I recall, many were humorous, heartwarming and even heart-wrenching accounts. Yet the very best part was seeing it all through the eyes of a child.

Catherine Spriggs Boone and her family visited Santa Claus at Miller & Rhoads every year when she and her brother, Creed, were children. They continued the tradition even as they grew older, visiting with their mom and dad, Gale and Don Spriggs. On occasion, their grandmother, Virginia Spriggs, would come at Christmastime from Greensboro, North Carolina. She would join in the fun at Santaland with her family and enjoy sitting on Santa's knee. Mrs. Boone said that it was her late Grandmother Spriggs who kindled in her a belief of magic and whimsy at a young age. She said this belief made her trips to Miller & Rhoads even more meaningful, and she relishes the memories of those visits.

Now a young mother herself, she wrote:

> *I can take myself back in time and try to recapture all my memories and thoughts about the magic of Santa and the Snow Queen…I remember just being in awe of you every time I would go see Santa. I wanted to be just like you. You were the most beautiful doll I had ever seen and your voice was so*

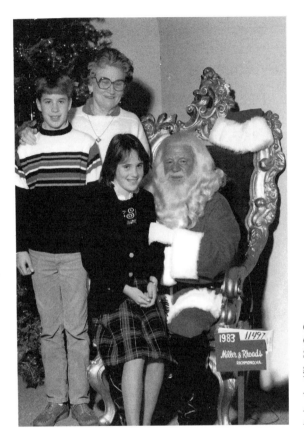

Creed and Catherine Spriggs with their grandmother, Virginia Spriggs, visit Santa, 1983. *Don and Gale Spriggs Private Collection.*

sweet and soothing. Oh, and your dress!!! That dress was just gorgeous! It was dream-like. I remember being scared to touch it, because it was just so beautiful. I guess like all the children, I really believed in you and I just could not believe that Santa remembered my name every year. He not only remembered my name, but certain things about me. It really was like walking through a fairy tale book or fantasy land to be there.[26]

Santaland did evoke the idea of a fantasyland to many people, especially children. Often the décor in the room would be snowflakes glistening and stars twinkling from the ceiling.[27] A festive holiday exhibit, often with animated figures, was tucked in a conspicuous corner to be viewed by visitors as the line wound, maze-like, through

the room. Even the temperature in Santaland seemed chilly, as a blue haze effect created by the paint hues was incorporated with impressive lighting techniques.[28] Thus, stepping into Santaland was entering into a dimension where a true sense of a "winter wonderland" became a reality. No doubt, Santa also felt at home in his temporary Christmas location. It was not the North Pole, but it was the closest thing to actually being there, and the children loved it.

Judy Lankford recalled her visit as a child and said she especially remembers the fairy tale atmosphere of the room. "The room was not a very large room I came to realize when I saw it later in my twenties—but to a child it was magic, magic, magic!" she said.[29]

Sabrina Rabon is now thirty-eight years old and a high school teacher. Her memories of the "wonderful times" she spent with her family at Christmas at Miller & Rhoads are still vivid:

> *I remember going up the escalator and the anticipation of seeing you as the Snow Queen and Santa. I remember the smell of the room, the Christmas decorations and the line that was endless, but never once did I think of whining or complaining to my mother!*
>
> *One of the last of the Christmas seasons that Miller & Rhoads was in business, and I was a college student, I asked my mother to go down with me to see Santa and the Snow Queen one more time in the old building. I spoke to you and thanked you for the memories that will never fade...*
>
> *Thank you for making Christmas special. As I write to you, I am tearing up remembering the Rudolph cake, having lunch, listening to the music, the laughter, listening to Santa gulp his milk and listening to you sing and Mr. Weaver playing the organ.*
>
> *There is one Christmas that I remember fondly. My cousin Duncan and I were twelve, and that year I went to see y'all and we had just sat down for lunch and my aunt and uncle gave my cousin and me an early Christmas present. They were expecting a baby, a sister for Duncan, and a new cousin for me. We were thrilled. Now my aunt has passed away. Christmas was her season, so having that memory is very special.*
>
> *Thank you for all you did, and thanks will never be enough. You made Christmas and what it means to me.*[30]

Some visitors considered waiting in line to see Santa as part of "the experience." Many folks viewed it as fun and thought of it as a way to help build the excitement to reach their ultimate goal. Others thought of the line as something that had to be tolerated to reach a reward—a visit with the Snow Queen and the very famous Santa Claus.

Denise Cosner vividly remembers her Santaland experience with her son Josh and niece Ashley in 1989:

> *I can still feel their anticipation and excitement of waiting in line to see the Snow Queen and the legendary Santa. All the many emotions that were innocently radiating from them, flowed over to all the parents in line with their new camcorders (which are now antiques in our digital world) all charged. The parents were hoping the battery would last from the time it was their turn to chat with the beautiful Snow Queen in her long flowing white gown until the time they slid off Santa's lap and ran into the arms of their Mom or Dad.*

Ashley Trammel (left) and Josh Cranor anxiously wait in line for their turn to visit Santa at Santaland, 1989. *Denise Cosner Private Collection.*

Then there were the 35-mm film cameras that Josh and Ashley have no memory of…that resulted in the "not so good pics" of Santa and the Snow Queen.

It's ironic that the time we dreaded the most—waiting in line at Miller & Rhoads—that anticipation and excitement—ends up to be my most treasured memory.[31]

Often if the same families would visit on the same day every year, old acquaintances were renewed. It was common to see someone you knew or at least recognized while waiting in line.

"It was like a community atmosphere, because everyone was in the same boat," said Cindy Padden, who visited every year after moving to Richmond from Chicago. She began seeing Santa with her two boys in 1987. "I was still breast feeding the youngest son," she added, "and I would leave the line to go to the ladies' room with my baby boy. My friend who had come along with me would watch my other child and save our place in line. We would rejoin them and continue the long wait. But it was worth it because we were so into the Santa experience!" she said convincingly.[32]

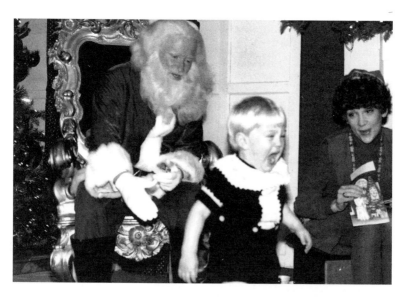

Tyler Padden had a short visit with Santa, 1989. *Cindy and Steve Padden Private Collection.*

The only time anyone would be able to go to the head of the line was on the occasion when the visiting child had a physical disability. If this was the case, special arrangements were made so the child could have his or her turn to see first the Snow Queen and then Santa without having to endure a long waiting period. Also, if a photograph of any visit had to be a "retake," which was rare, the child or group could have it done quickly, without waiting.[33] Coming back a second time may have been an inconvenience; nevertheless, it would afford the benefit of another visit with Santa. (An added bonus might be the opportunity to whisper one more item on the wish list that had not been revealed the first time around!)

One family had the opportunity of not having to wait in line to see Santa under special circumstances in the 1980s, according to one former Miller & Rhoads executive. Representatives from the Collegiate Schools approached the store management and asked if M&R could offer a unique item for the school's annual benefit auction. It was decided that the store would offer "dinner in the Tea Room and no waiting in line to see Santa for ten people."[34] The former executive recalled:

> It was a challenge to coordinate all of this, and it was decided that the thing to do was situate the parents in the back of the Santaland room to watch. We decided the best route to get the children in to see Santa was through the store's clinic, or infirmary as it was called, which was located adjacently to Santaland. A door opened directly from the infirmary to the backstage area of Santaland. Discreetly, the children were escorted by me personally through that back way. As we approached the Snow Queen, I asked the children and their parents waiting next in line if the children with me could have a retake, and of course, they kindly obliged. I just remember I kept saying the word "retake," and the children had their visit with Santa. The family who won the winning bid for the dinner and no waiting to see Santa paid $750. Even more interesting is the same family bid on it the very next year, and had the exact same winning bid!

On rare occasions, the end of the waiting line would have its origin on the sixth floor, and groups were shuttled via elevators to the seventh floor. Arriving there, one's place in the line began again; however, it was a relief to waiting visitors to finally progress up to that last floor. Once there, folks at least would have the satisfaction of being in sight of their destination—Santaland. But at that point the waiting continued, and it could be another two hours before seeing the Snow Queen and Santa.

The long lines would deter some parents from carrying out their mission of a visit for their children with the Miller & Rhoads Santa, especially if the youngsters in tow were growing tired and restless. On occasion, parents would wait in line for what seemed like forever, only for the little ones to refuse their visit with Santa once they approached him.

Gayle Orange wrote about her childhood visit to Santaland with her Auntie Reese:

> *Auntie patiently waited with me in line as we inched our way up to the Snow Queen. I was finally almost to where Santa was sitting when suddenly I told Auntie I didn't want to talk to Santa that day. She tried and tried to get me to overcome my shyness, but sadly I gave in to panic and we left.*
>
> *I wonder how many other parents and family had to deal with children who had last-minute jitters*[35]

Kathy and Rick Streetman, high school friends of mine, made their annual trip downtown during the holiday season. "We usually ate in the Miller & Rhoads Tea Room and—we were so bad—went to Thalhimers to stand in a much shorter line for Santa," said Mrs. Streetman. "I had a sister who was twenty years younger than me and only five years older than my oldest son. We would all enjoy going together to see you as the Snow Queen and Santa in the Tea Room. My sister was always so amazed when you knew her name and talked to her personally! That was the greatness of knowing the Snow Queen."[36]

But it was the sweetness and sense of wonder surrounding the entire Miller & Rhoads Christmas experience that folks remember

Santa greets children at the Rudolph cake table in the Tea Room, 1989. *Janet Pritchett Private Collection.*

and still talk about today, especially if they were children at the time. Although the store closed in 1990, recollections remain fresh and true, and such testimonies are common. The following one is from Laurie Evans Pancer, now of Atlanta, Georgia, who visited M&R at Christmas from 1972 to 1980:

> *I have many good memories of my childhood, but none can compare to the memories I have of Santa & the Snow Queen at Miller & Rhoads. Every year my parents would dress my two brothers and me up and we would head down for a day to see Santa. Now, having children myself, I realize that for my parents it was an enormous feat to get us dressed and there without wanting to kill all of us!!*
>
> *Arriving at Miller & Rhoads, we would wait in the long line, with us hanging on the ropes, whining and complaining and wondering when it would be our turn. It would be just when my parents had every nerve plucked out of them and we were on our last warning that we would hear the jingling of Santa's bells. Then in amazement we would watch Santa come down the chimney and shout "M e r r y C h r i s t m a s!" I can still hear*

the sound of his voice! We would continue waiting in line until we reached the beautiful Snow Queen. Of course since I was the only girl, the Snow Queen was the most beautiful girl with the most spectacular white gown. We would talk with the Snow Queen for a couple of minutes.

Then the next part was the most amazing thing of the whole experience. Santa would call us over and say, "So, Lauri, Scott, and Greg, tell me if you've been good this year!" We were awestruck that he always remembered our names!! As my youngest brother cried while sitting on Santa's lap, my brother and I reeled off our list. All of the waiting was worth it for us and I'm sure my parents, too!

We would then go to the Tea Room to have lunch with Santa, the Snow Queen, and the Elf. Another long line, but once we reached the entrance and could hear the organ music we knew the cake that Santa and Rudolph made was not far away! I remember Santa sitting up on the stage at the long table with the Snow Queen and the Elf. We sat at the huge round tables and my mother always ordered a club sandwich. We would eat, all the while waiting for Santa to stand up and give his speech. All I remember is him saying that Rudolph made the cake stirring it with his hooves!! Then he would come down off the stage and help serve it to all the children.

After we finished lunch we would go to the Fawn Shop (where children could shop). We would then go to Thalhimers across the street and see their "Wonderland." I remember walking into the dimly lit room and look at each winter scene that had a special blue light which made the snow glisten. That would be the end of our day-long trip, nothing short of a magical visit to Disney World!!

There is nothing that compares to my memories of Christmas in downtown Richmond. I can picture it like it was yesterday. I only wish that my children could have the same memories. Instead we struggle with getting them dressed, drive 30 minutes to go to the "fancy mall" where we have a scheduled appointment with Santa. We wait in line, not an Elf or Snow Queen in sight. The

children briefly sit on a Santa's lap who doesn't even know their names. Snap a picture, and the day is over. I have always said my mission in life is to bring the Snow Queen, Santa and the Tea Room to Atlanta!

I have sat with tears running down my cheeks while writing this!![37]

Pat Carreras, a longtime visitor to the store, still lights up with enthusiasm when she remembers Christmas at Miller & Rhoads. "I visited the store as a child in the 1940s, and in the following years I visited with all my nieces and nephews," said Ms. Carreras. "It was all so special! The children were all dressed in red. There was Santa, the Snow Queen, Eddie Weaver, the Tea Room, Rudolph cake…all such great memories."[38]

Indeed, the Miller & Rhoads experience at Christmas was "all about the children."

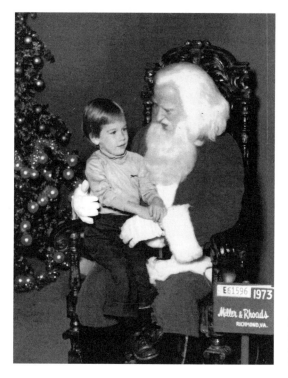

Mark Gammon visits with Santa, 1973. *Lila C. Gammon Private Collection.*

Going to See Santa. Print by Richmond artist Stuart Pendergraft White, 1995. *Stuart White Private Collection, www.uptownartgallery.com.*

Gail Faucett, in recalling her memories, commented, "Magic rarely strikes in one's lifetime. But the Santa visits and the whole experience, from beautiful decorations to pretty snow queens, were truly magical."[39]

Youth may pass quickly, but thankfully beloved memories linger. The reflections of those days are endearing and oh so comforting.

"Ho, Ho, Ho!": The Humor of the Children

The sound of Santa voicing "Ho, Ho, Ho!" and "Merry Christmas!" filled Miller & Rhoads's Santaland as he arrived, coming down the chimney to the delight of both children and adults. The familiar greeting also echoed through the Tea Room as he made his entrance for lunch or dinner with the Snow Queen and Elf. But Santa's "Ho, Ho, Ho" may have been the most boisterous when he was surprised by a child's wish request or a youngster's unexpected aspect of fun and whimsy.

While working as the Snow Queen one Christmas in the 1970s, I remember laughter from the visitors crowded in Santaland. A little boy, about three years old, professed only one wish. Santa greeted Will by his name, and once the lad was situated on his knee, the jolly elf asked, "Well now, tell me what it is you would like for Christmas."

"A box of raisins," Will replied quite seriously. Santa repeated Will's answer with a questioning tone, as if not hearing the little fellow's request correctly.

"A box of raisins?" he inquired again.

Will nodded yes.

Santa smiled and said, as if caught off guard, "Okay, anything else?"

Will shook his head no and said once more, "I want a box of raisins!"

Will's mother was watching her son from the audience in the first row of the chairs located directly in front of the stage. "That's right, Santa. All he has asked for is a box of raisins!" she confirmed as she shrugged her shoulders.

"Ho, Ho, Ho, well that's fine!" said Santa to Will in a reassuring voice. "Raisins taste good and they are good for you!" he added. "But I'll see if I can find some surprises to put in your stocking and under your tree too, okay?" Santa hugged the boy and gently slipped him off his lap.

Will started to walk toward the ramp from the stage en route to his waiting mother. Santa called out, "Wait Will, Elf has something for you!" Will suddenly stopped and happily grasped the candy cane and coloring book that the Elf presented him. Santa shouted a hearty, "Bye, bye, Will," as the boy walked down the ramp. He waved goodbye to Santa, and his mom prompted him to say "thank you," which he did with confidence. He no doubt felt certain that he would get his one wish: a box of raisins. To this day, I never eat a box of raisins without thinking about that cute youngster and his unusual request!

Often Santa was surprised by what the children asked for, but perhaps not as surprised as the parents themselves. June Adams, a longtime friend of mine, recalled her favorite visit with her son to see Santa and me as the Snow Queen:

> Duncan was about six years old, and my Aunt Joyce and my mother, Dorothy Parker, were with us. Well, Duncan asked Santa for a bird for Christmas, and Santa said "Ok!" I still remember my Aunt Joyce asking me as we walked off the Santa platform, "Lord, June, what are you going to do?" I had never owned a bird before in my whole life and knew nothing about them. I told her I guessed I'd have to find a damn bird! So, Duncan got a parakeet for Christmas he named "Birdie," who lived three or four years, and was a really fun addition to the family, except for when Duncan would slip and let him out for some exercise![40]

Often it was not just what the children would say to Santa that was funny. The long wait in line sometimes produced interesting conversations among the children themselves.

Carol Mancuso recalled the year she took her son Anthony to visit Santa when he was about six years old. He had brought his friend Paul along with him. Mrs. Mancuso explained that Paul had two older brothers who apparently were an influence on his ability to believe in "the magic."

"The entire time we were in line, Paul kept saying 'there is no Santa Claus, it is your mom and dad,'" she said. "My son just kept looking at him and when they got fairly close to Santa, Anthony said, 'Well, if you don't go and see Santa Claus, we'll see how many presents you get for Christmas!' Paul looked at him and went right up to see Santa Claus! The magic of always believing!" she added.[41]

When visiting Santaland on some occasions, the humor was not only what the children *said* but what they *did* when they finally reached the Snow Queen and Santa.

Becky Deal Long, who was a Snow Queen in the 1980s, recalled a little boy of about three years old. She spoke to him as he approached her and she relayed his reaction:

> *He looked nervous, as many children are about seeing Santa. The red suit, the beard, the large, ornate chair…it can be a little daunting. He was waiting for that moment when Santa would turn, recognize him and call him over by name. Finally, after Santa finished visiting with the previous child, he turned and called the little boy over by name. A moment of stark terror crossed his little face and he turned to me, lifted up the front of my skirt and dove under it to hide!*[42]

Donna Hudgins, a friend and former college roommate of mine, would try to find out when I was on duty as the Snow Queen. Donna and Carter Hudgins and their children, sons Carter and Cary and daughter Caroline, would make their annual visit from Fredericksburg. It was always a thrill for me to greet them. One year, they were unable to visit M&R at the time I was working. The boys had grown older and, for their little sister's sake, were instructed by mom and dad to "play along" and continue to believe in the magic.

According to Mrs. Hudgins, they were disappointed that they would not see me as the Snow Queen when they could come. But

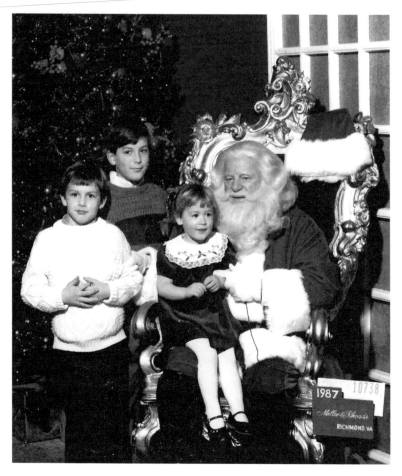

Cary, Carter and Caroline Hudgins visit with Santa, 1987. *Donna and Carter L. Hudgins Private Collection.*

Carter and Cary saw an opportunity to play a trick on Santa by giving the Snow Queen on duty, who did not know them personally, some made-up names other than their own. "Of course, I couldn't believe they did that, but they sometimes were mischievous, as boys will be!" she laughed. "Usually when we visited and saw you as the Snow Queen before seeing Santa, everything went smoothly, but not that year!"[43]

Sometimes the Snow Queen would receive notes just prior to a child's visit. The notes would be from parents or others accompanying the children, warning that the little visitors were attempting to play a joke by giving pseudo names to the Snow Queen. The notes clarified the real names.

Caroline Stowers relayed the story of a friend whose child's planned prank backfired, as the Snow Queen received a note from the parent giving the child's true name. "The little boy was blown away when, after he gave his 'fake name' to the Snow Queen, Santa actually called him by his real name," she explained. "That moment most certainly was good for another year of believing!"[44]

Funny instances that only parents would notice made for truly humorous stories years later. Ann Ashton revealed one such story as she wrote:

> *It was 1973 or 1974. It seems like a long time ago now. We always brought our two children "down" to see the real Santa. When our son was about 6 years old, we made the familiar trip, had a wonderful dinner in the Tea Room (usually the chicken pot pie) and lined up to see Santa in Santaland. Beth and Steve were all dressed up, as we kept all of the Christmas pictures.*
>
> *The children went up and talked to the Snow Queen separately. When Santa called Steve up by his name, he went across the platform floor with his eyes downcast. He was looking for the cord he thought he would see so he could understand how they knew his name. I still remember the expression on his face and the fact he was walking backwards towards Santa, still looking for the cord!*[45]

Humorous antics by the children were not limited to Santaland. The Tea Room, where Santa, the Snow Queen and the Elf enjoyed having lunch and dinner with children and adults, often produced circumstances of mirth.

One of the funniest recollections I have took place while dining with Santa in the Tea Room in the 1980s. As the Snow Queen, dining was an extension of the production. It was a busy Saturday, typical for most Saturdays during the holidays. Santa, the Elf and

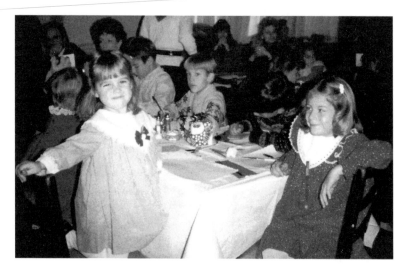

Meredith Adams (left), Kelly and Garrett Cline and Megan and Matt Merson lunch with Santa in the Tea Room, 1988. *Harold and June Adams Private Collection.*

I had made our entrances and taken our places on the stage. Santa already had greeted the enthusiastic crowd. He introduced us, and then he graciously escorted us to our seats at the elegant tables.

Santa then marched up to the microphone and proceeded to perform his routine of drinking his milk. This was always viewed as a treat, delighting the children as he gulped his milk and emptied his glass, accompanied by Eddie Weaver's whimsical organ antics. The excited audience roared with applause. Santa jumped up and down to make sure his milk had settled in his tummy and commented out loud, "Hmm...that was good!" He then joined me at the table.

Previously, we had placed our lunch order, and soon our meal was served to all three of us at the same time. We enjoyed eating while waving to the audience, and they returned the friendly gestures. Christmas songs resonating from the organ sweetened the atmosphere even more.

After we had finished our lunch, Santa again stood up and approached the microphone. He made an announcement about the special dessert that was a tradition served every year:

You know boys and girls, Rudolph has been very busy baking something special for all of Santa's babies. Rudolph takes his hooves and he mixes up some dough for me, and makes a cake. He told me, "Santa, please give all the children who come to visit you in the Tea Room at Miller & Rhoads a piece of the cake." Well, I have some of the cake that Rudolph made, right down here at the end of the runway! Now, if all of Santa's babies will join me, I'll give you a piece of the cake! Come on down, Doll Babies!

With his encouragement, all the children in the Tea Room hopped out of their seats from the tables. They eagerly made their way to the large, long table situated at the end of the runway. It was deliciously set with pieces of Rudolph cake.

Santa traveled the runway toward the gathering children and took the few steps down to the Tea Room floor to join his admirers. The smallest youngsters were accompanied by an adult, usually a parent or family member. Santa carefully passed out piece after piece of cake to the excited little ones.

As soon as he made certain that all had received their share, the jolly ole' elf laughed a hearty "Ho, Ho, Ho!" He maneuvered his way back up the steps to the runway and onto the stage area. He waved to the throng and reached our table, where he took his seat next to me.

As we continued to smile and wave for a short while, it looked as if the crowd had turned over and another room full of diners had been seated. Santa knew that he needed

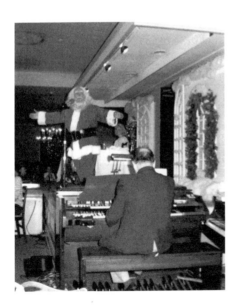

Santa and Snow Queen Donna Deekens on the Tea Room stage, accompanied by Eddie Weaver on the organ, 1988. *Santa Charlie Private Collection.*

to offer the Rudolph cake to the children who had recently arrived. He knew that he had to do so before we left the Tea Room to return to Santaland.

Santa was getting ready to rise from his chair, but before doing so, he said to me in a discreet but somewhat concerned voice, "Snow Queen, I think I am stuck to my chair. I can't get up!"

I was sitting on Santa's right, and I said, "What Santa? Are you all right?"

Santa continued, "I will raise up my right backside. Will you see if you can see anything?"

I tried to look down to my left to Santa's derriere without being too obvious. As he raised up slowly, leaning slightly to his left, I noticed a big pink blob of something stuck to his pants.

"Santa," I whispered, trying not to alarm him. "It looks like you have a big wad of bubblegum on your pants, and that's why you are stuck!" We both had a good idea how it got there.

"Oh my," said Santa with a somewhat worried look. "I'll try to pry it loose with my fingers."

As he worked with his right hand to attempt to dislodge the gum, he waved with his left hand to the children. I waved alternately with both hands and smiled, all the while trying to follow Santa's progress.

"I think I'm loose from the chair now," he said in a tone of relief. "Can you see if the gum is still very noticeable?"

Once more I cast my eyes downward as Santa again leaned to his left so I could get a better view of the damage. "I think you are no longer stuck, Santa," I confirmed, "but the pink wad of gum is still noticeable."

"Well," said Santa decisively, "I'll make an announcement that I have to check on something behind the stage here for a few minutes. You and Elf come with me and let's see if we can get anymore of this stuff off."

Before Santa made his announcement, he summoned Eddie Weaver up to the stage to talk with us. We explained the "sticky" situation to him and asked if he would summon a waitress to bring us some ice backstage to try to remove the gum. Weaver briskly left the stage to fulfill our request. He voiced his recognizable "Ha!" and

presented a wide grin and laughter as he practically skipped back down the steps.

Santa stood up cautiously from his seat, careful not to reveal his backside, and walked to the microphone. He made his announcement to the crowd. "Boys and girls," he called, "I have to check on something behind the stage here for a few minutes regarding the reindeer. Enjoy your lunch, and we'll be right back."

He came up behind my chair and helped me out of it in his gentlemanly fashion. I motioned to the Elf to join us. Santa went backstage first and I closely followed, attempting to shield his pants from the crowd.

We arrived backstage, which was a small area usually reserved for M&R models to change during fashion shows. A Tea Room waitress awaited us with a glass full of ice, a spoon and a cloth napkin. We thanked her, and I immediately picked out a large piece of ice. As Santa held up the back portion of his coat, the Elf pulled on the upper part of Santa's right pant leg as I ran a piece of ice over the gum plastered to the red velvet of the seat of his pants. I continued to rub the ice, and the major chunk of the gum froze and came off; however, a few remnants remained. We concurred that it would not likely be too noticeable.

Hurriedly, all three of us returned to the stage, waving as we entered. Immediately, we heard cheers from the diners and impish chuckles from Eddie Weaver as he tickled the organ's keys. Santa helped us back to our respective seats. He then walked to the microphone.

"Hi again, boys and girls!" he said in an ecstatic voice. "Some of you may not have been here a little while ago, when I gave out some of the cake that Rudolph helped to make. You know, Rudolph told me, 'Santa, when you see the children at the Tea Room in Miller & Rhoads, be sure to give them a piece of the cake!' Rudolph takes his hooves and he mixes up the dough for me," he explained. "I have some of the cake right down here on the table at the end of the runway," he said, pointing in that direction. "So come on, Santa's babies, and get a piece of the cake! Come on Doll Babies!"

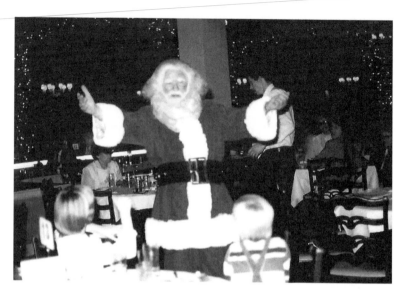

Santa greets children during lunch in the Tea Room, 1988. *Ritchie and Donna Johnson Private Collection.*

With that invitation, the children from this second seating bounded from their tables, and some parents accompanied them. Santa presented Rudolph cake to the happy faces. He checked and made certain that all the children had received some cake and then headed back up the runway steps.

Walking directly to the microphone, Santa announced, "Well now, boys and girls, Santa has to go back up to the roof to check on the reindeer. Be sure to come see me in Santaland. You be good now, and remember ole' Santa loves you! Bye, bye—and Merry Christmas!"

Approaching me to help with my chair, Santa said, "All right, Snow Queen." Then he summoned the Elf to come along. We walked down the runway, as if in a parade, down the steps and past the Tea Room tables. Everyone waved to us, sporting wide smiles and twinkling eyes.

We made our way out of the Tea Room and hopped aboard the fifth-floor escalator, waving to onlookers. As we rode up to the seventh floor, we chatted and laughed about "the sticky situation" that had just occurred.

"That bubblegum had to have been planted on your pants by a child the first time you gave out the Rudolph cake," I said to Santa. "Can you believe a youngster would do that?" It was a question I asked him with a look of almost disbelief, which he detected.

"You have to be ready for anything and everything!" he replied with his belly laugh, a twist of his head and the familiar wink of his eye. It was evident to me that he saw the humor in it all, even in the mischief. As the beloved Christmas poem "The Night Before Christmas" reads, "we had nothing to dread."[46]

Most definitely *the magic* also could be found in the humor of the moment, and there were many times of amusement and merriment when those moments rang true.

Christmas Visits that Melted the Heart

Santa, the Snow Queen and the Elf visited with so many dear children every year. Delighted by all who came through our doors, it was amazing to see such a cross section of people—from tiny newborns to the "youngsters" in their nineties and those in between. All folks who visited with us seemed to realize the importance of the magic in believing.

The spirit of Christmas for me was never more evident than one particular year in the 1970s when I was the Snow Queen working the evening shift. It was getting close to the end of the holiday season at the store. That evening, I distinctly remember that it was almost closing time and the crowd in Santaland was dying down. A young lad, about age eleven, came into the room alone. He appeared poorly dressed but confident that he was in the right place. Slowly, he made his way toward the front of the room where the chairs faced the stage, and he sat down. Keenly, he observed Santa conversing with a little girl sitting on his lap. She appeared to be the last visitor of the night, as no one else was waiting in line. As she completed her visit and left the Santaland stage, Santa acknowledged the young fellow who sat quietly and said, "Hi there! Come on up!"

The boy seemed surprised when Santa spoke to him. "That's right, come on up and see my Snow Queen first," Santa suggested, as the youngster arose reluctantly from his chair. With a sheepish and less than eager gait, he approached my chair.

"Hi," I said, as I softly but happily greeted him. "What's your name?"

"Leon," he replied.

Santa immediately chimed in and said, "Well, Leon, I'm glad you decided to come see old Santa! Come on over!" Leon smiled and seemed intrigued that Santa had called him by his name. He left my side and shyly walked toward Santa's beautiful yet somewhat imposing chair. Santa quickly seemed to put the young man at ease, and at Santa's urging, Leon sat on his knee.

While Santa and Leon chatted, I noticed that there were no other children waiting in line to talk with me. I glanced out into the almost empty room and saw a few adults sitting and watching Santa "at work." Often, there would be adults and sometimes children simply sitting in the chairs facing the stage. They could easily observe the interaction and hear the conversations, as Santa would talk with a child using a hand microphone. All who watched seemed to take everything in, fascinated by the moment.

On this particular night, I noticed a lone, well-dressed gentleman sitting toward the back of the room. He had arrived earlier when there was a larger crowd, and he had remained for quite some time. He obviously enjoyed watching the excitement of the children and their exchanges first with the Snow Queen and then with Santa. As the room emptied, the gentleman was still there and seemed to be intently interested in the conversation between Santa and Leon.

Santa continued talking with the young man and took more time than usual with him, since there were no other children waiting. Pointing to the camera, Santa said, "Look right there, Leon, and smile!" The photograph was taken. "Good!" boomed Santa. "Well now, Leon, have you been thinking about what it is you would like to have for Christmas?" he asked.

"A drum set," replied Leon, answering in a firm voice, with no hesitation.

"A *real* drum set?" Santa asked with a surprised look.

"Yes," said Leon emphatically, speaking into the microphone that Santa was holding up to his lips.

"Well, my goodness," said Santa, somewhat taken back. "That's a pretty big order now, isn't it?" Leon answered him with an

affirmative nod of his head and a softly spoken, "Yes." Santa continued addressing the fellow, who seemed focused on what Santa was saying. "Well, you know, Leon, ole' Santa can't always bring everything his boys and girls ask for. Sometimes I just can't bring exactly what you want. But I'll certainly see what I can do. Now you be good, and I'll be coming by, and remember, ole' Santa loves you!"

Leon said, "Okay," and left the stage after the Elf presented him with a candy cane and coloring book. He traveled down the ramp of the platform and was directed to the corner counter to see if he would be interested in purchasing his photograph that was taken with Santa. He did not purchase a picture, but it was customary for everyone to leave their name, address and telephone number. This was in the days before digital cameras, when film photographs were the norm and were mailed to visitors who purchased one or more copies. Inevitably, someone who did not purchase a photo at the time it was taken would contact the store later and request to purchase their picture. So, Leon's name and address were taken down and put on file. He left Santaland alone, with no parent or guardian in sight, but with a look of contentment on his face.

The nicely dressed gentleman in the back of the room seemed to be especially interested in the meeting that took place between Santa and the child, for he stayed and witnessed the entire encounter. He soon left the room too, as it was time for Santa to go up the chimney, back to the roof to check on the reindeer and bed them down for the night. Also, it was time for Santaland to close for the evening. But apparently the mystery gentleman did not leave before he found out from the Santaland employees what he could about Leon, who had revealed his wish to Santa.

After the Christmas season ended that year, I learned from some Santaland staff working that night an amazing addendum to the story of Leon's visit. It was discovered that a real drum set had been delivered to the little boy at his home in Richmond's Jackson Ward neighborhood on Christmas Eve. We all knew it had to have been the generous gift of the anonymous man who was in the back of the room on the night of Leon's visit. Somehow

Brent (left) and Greg Deekens, sons of Snow Queen Donna Deekens, with Santa at Thalhimers, 1990. *Bill and Donna Deekens Private Collection.*

he acquired Leon's full name and address and felt compelled to ensure that the child's wish of a real drum set would come true. We were all moved by this gesture of kindness shown by this man to a child he did not know and would probably never meet. This is what the spirit of love and giving was all about, and it was all around us, especially at Christmas at Miller & Rhoads, even if we did not realize it at the time.

I often wished that I could have seen Leon's face when the drum set was delivered to him at his home. I am sure there must have been tears of joy flowing not only from his eyes but from those of other family members as well. I know tears of happiness were flowing from my eyes when I heard the news, and also a wondrous reaffirmation that there are good and caring people still in the world.

Michael and Amy Jones and the *real Santa*, 1982. *Ron and Judy Jones Private Collection.*

Memorable, touching visits were woven throughout the tapestry of my years at Miller & Rhoads. As Snow Queen, I always looked forward to greeting my husband and our sons, as well as my niece and nephew. Also, it was great fun to visit with the children of my friends from both my high school and college days.

Santa and the Snow Queen loved meeting with all the children; however, no visitors seemed more thrilled or more appreciative to spend time with us than the mentally disabled children. Often the children who were mentally challenged, especially those afflicted with Down syndrome, were so very loving and affectionate. Their excitement was joyous to witness, and sometimes they were almost uncontainable. Many times they wanted to sit in my lap when they would first visit with me as the Snow Queen before seeing Santa. Gladly, I tried to oblige them when they attempted to crawl in my lap, even though some children were almost as big as me! I welcomed hugs and kisses from them as well. They wanted to touch my tiara and run their fingers over the skirt of my gown. If they were girls, often I heard the sweet compliment, "You're pretty!" It was like music to my ears. I am certain those tender children never understood the fact that their visits probably were more meaningful to me than to them. I know that Santa felt the same way.

On occasion, there were some special situations that had to be delicately managed. Thusly, adaptations had to be made when physically challenged children came to visit Santaland. One loving story that quickly circulated among the Santaland staff involved a five-year-old boy who had been stricken with polio. The visitors in line waiting to have their turn with the Snow Queen and Santa were asked to wait a little while longer so that this child did not have to wait in the long line due to his disability, and folks were eager to help in that regard. The lad had been wearing braces all his young life since learning to walk. But for this special visit to see Santa Claus, he was insistent on walking to the Snow Queen and Santa without his braces. In the event that the determined youngster would not be able to complete his task, Santa and the Snow Queen had been briefed about the circumstances. The little boy began his walk, with everyone who

Snow Queen Donna and husband Bill Deekens pose with Santa, 1980. *Bill and Donna Deekens Private Collection.*

was observing holding their breath. He made it about a third of the way and collapsed as he met the waiting Santa, who greeted him with open arms. We heard that "there was not a dry eye in the house."[47] How I wish I had been the Snow Queen on duty that day!

Judy Lankford remembers visiting Santaland as a child after she had just recovered from rheumatic fever. "The Miller & Rhoads folks found out that I still wasn't supposed to stand for a long time," Ms. Lankford said. "So they moved me to the head of the line—*and* Santa went back and came down the chimney again, which he had already done earlier. It was an even more special experience that year!" she noted.[48]

More often than not, going to see Santa managed to elicit happy endings, despite what transpired during the visit. Sometimes situations would arise that were not planned by the visitor and unexpected by those of us working in Santaland. The majority of visitors usually left Santaland seemingly content, departing with laughter, smiles and sweet goodbyes. Some children showed signs of getting tired by crying, while others were a bit frightened. They would express their feelings with little whimpers and cries and even what might be perceived as tears of joy. Many times, those tears of joy were very real, and they were not from the children, but from the adults accompanying them.

Linda James said that she was expecting a child in the late 1970s but lost her baby late in her pregnancy during Christmastime. She also had two adopted children, Michael, age seven, and Jill, age four. She wanted them to go to Miller & Rhoads to visit with Santa, but she was not physically or mentally able to take them. She was especially concerned about her son Michael, for it seemed that he was on the verge of not believing in Santa. Mrs. James asked her cousin, Jo Gates, and her husband, Johnny, to take the children to the store to see Santa Claus. She further explained:

> *Jo agreed with me and my husband, Rodney, that it was important for the children to visit the real Santa, especially with the doubts that Michael was experiencing. Jo and Johnny*

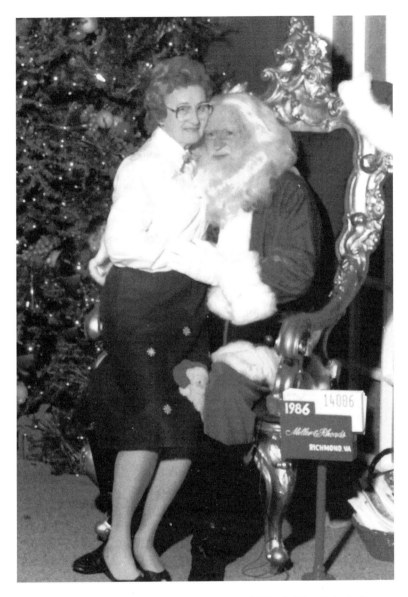

The legendary Santa enjoyed visitors of all ages at Miller & Rhoads, including Frances Hood, 1986. *Frances M. Hood Private Collection.*

*had already taken their own child to see Santa a few days
earlier, and he was not with them this time. Santa recognized
Jo and said, "Mrs. Gates, you were here with your son just a
few days ago, and these are not your children!" Michael was
so surprised and seemed perplexed that Santa knew that he
and Jill were not the children of the Gates, even though they
were related. That visit convinced Michael that this was the
real Santa, so the belief was sealed for another few years!*

Mrs. James said that Mrs. Gates relayed the fact that Santa told
the children a special story that he sometimes included in his visits
with the children. He told them that he would try to peak into their
bedroom on Christmas Eve when they were sleeping. If he did have
time, he would touch their foreheads and leave a spot of soot (which
he explained would be remnants of what he would get on his gloves
when coming down the chimney). He told them that if they woke
up on Christmas morning and discovered such a mark on their
foreheads, that would be proof that he did have time to see them
briefly on his busy night.

"It was so lovely for the children and very moving for us all," said
Mrs. James, "and it was special for me and my husband too since it
had been a difficult time for us. It was wonderful that Santa helped
Michael continue to believe for a while longer. The story Santa told
about the soot made it so much more meaningful since we could not
be with them during their visit," she added. "I understand Michael
was completely befuddled," she laughed. "The visit that year is one
we will always hold dear."[49]

Children's heartwarming visits especially touched all of us who
worked in Santaland in the early 1970s. The Vietnam War was
raging, and it was not uncommon for children to visit Santa and
ask for the safe return home of their fathers. No doubt Santaland
helped people escape the war, if only for a short time. In the early
1990s, when Santaland moved to Thalhimers, a different conflict,
the Gulf War, produced similar requests expressed to Santa: "My
wish is for my daddy [or mommy] to come home safely."

It was difficult not to tear up when a child asked Santa for such a
wish, knowing that this request was more important than a toy for

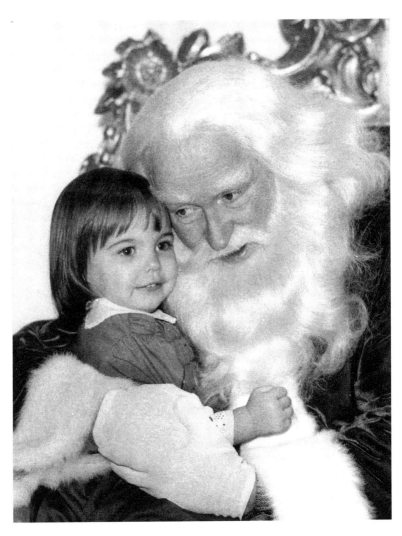

A little admirer appears enamored with the *real Santa* at M&R, 1984. *Courtesy* Richmond Times-Dispatch.

Santa at Miller & Rhoads. Pen-and-ink print by artist Sandra Jett Ball, 1991. *Sandra Ball Private Collection, www.sandraballart.com.*

er & Rhoads

gh Jett Ball

Christmas. It was a poignant moment. Always, my prayer would be that the child's wish would be granted and they would have the safe return of their loved one. I never knew for certain, but their hope was inspiring.

Other meaningful wishes were touching as well, such as "I want my mommy to get better," "I want my daddy to get better," "I want my dog to get better" and "I want my kitty cat to get better." Such statements usually were unprompted by a parent or guardian but were sincere and straight from the heart.

Brenda Long, a Snow Queen from 1987 to 1989, recalled a profound memory:

> *One special evening, Santaland was closed to the public as we were expecting some special visitors. A group of kids from the Children's Hospital was coming to see Santa! Seeing their little faces as they entered the room, completely wowed by the decorations and lights, they were awestruck and so excited! One-by-one they came to sit in Santa's lap or were wheeled in front of him for a special visit. Santa took his time listening to each child, hearing their wishes and thoughts, patiently answering their questions about his reindeer as they were touching his fur collar while staring down at his big, black boots.*
>
> *They were just like the other children who came to see Santa, occasionally asking for their favorite gift idea…but one request brought tears to the eyes of all who were there. This child asked for a new liver. I forget exactly how Santa responded to this request, but I do remember being impressed by what he said. Such graciousness and sensitivity made him the legendary Santa at Miller & Rhoads.*
>
> *Memories like this still inspire me today to take time with my own daughter, to slow down and enjoy each moment that God has given us.*[50]

Those "glistening moments," as I like to refer to them, were aspects of the magic of believing. It happened then, in a more innocent, pre-9/11, yet troubling era. I would like to believe that it still happens at times in today's unsettled, volatile world.

It is these lessons that we can continue to learn from children—the sense of mystery, the commitment to trust and the expectation of promise. These qualities, interwoven with the power of faith and love, are essential beacons that can shine brightly in all of us—and not just at Christmas—if we will just embrace them, as does a little child.

The Wonders of the Tea Room

People who are familiar with Miller & Rhoads in the era of the grand department stores remember its stately structure as one of the cornerstones of downtown Richmond. Positioned in the convenient, central commerce hub, citizens and business leaders alike were drawn to the amenities of the times. There they could meet, shop and later dine in the pleasant, comfortable atmosphere of the Tea Room. This elegant area was like a magnet, and during the holiday season both Santaland and the Tea Room were paramount to the success of the downtown traditions.

In many ways, the Tea Room was almost a wonderland in its own right. It was an elegant, welcomed oasis any time of year; however, during the holidays it shone brilliantly in its own "snow globe" of fantasy and music.

Stepping into the Tea Room heightened the awe and wonderment of already wide-eyed children. Feelings of childhood bliss erupted again in adults who accompanied the children, or those without children who merely sought solace in sharing the Christmas spirit with the young and the young at heart.

Festive décor was evident around the large room, which regularly served eight hundred to one thousand people for lunch during the season. Dinner in the Tea Room usually was not as crowded, but nonetheless it was a treat for all in attendance. Shimmering lights and Christmas green wreaths rich with red bows hung invitingly around the room and on the stage, casting an almost phosphorescent glow.

To add to the seasonal ambiance, Eddie Weaver, a fixture at the Tea Room organ, played Christmas music. Familiar carols and holiday tunes echoed throughout the space. Sometimes children could be seen sitting next to Weaver, and with his encouragement, they would sing merrily along to his peppy accompaniment.

During the busy lunch and dinner hours, Weaver would get the nod from the Tea Room food service manager that it was time for Santa's much anticipated appearance. Santa, the Snow Queen and the Elf made their way from the seventh-floor Santaland to the fifth-floor Tea Room via a behind-the-scenes stairwell. This "secret" passage would sometimes elicit laughter from the three of us as we maneuvered our way down the two flights of stairs. Santa's bells would be jingling; I would be holding up the train of my dress to prevent me from falling; and the Elf would be careful not to lose her footing on the steps because of her pointy slippers. But this less-than-elegant route would allow us to make our entrances into the Tea Room undetected and properly introduced. The clandestine back way fed into the kitchen area. Our arrival was worth the smiles we would elicit, initially from the kitchen staff and then from the awaiting Tea Room visitors.

Snow Queen Donna Deekens and Santa chat with a Tea Room visitor before ordering lunch, 1974. *Geri Oliver Private Collection.*

To cue Santa's approach, the organ would break into the familiar "Jingle Bells." Santa made his grand entrance from the back of the Tea Room after winding through the china department. He shook his bell-laced belt in rhythm with the music while making his way through the dining crowd. All the while he was greeting the admiring children and adults with his "Ho, Ho, Ho" and "Merry Christmas," he wound his way up the steps

of the runway. While waving constantly and happily, he walked to the main stage and spoke into the microphone.

"Merry Christmas, Santa's Babies!" he shouted, addressing the audience with infectious enthusiasm. "I'm so glad you decided to come down to Miller & Rhoads to have lunch with me today!" His mesmerized admirers were all eyes and ears.

"Well," he continued, "I've just been up on the roof, checking on the reindeer, and they're all right," he said reassuringly. "They're stamping their feet and snorting," he said as he pantomimed the actions of his hooved companions. "They just can't wait for Christmas to get here! Are you excited about Christmas?" he asked.

"Yes!" was the exuberant reply from the audience.

"That's fine!" he responded. "And tell me now, have you all been *good*?" he implored.

"Yes!" was the loud reply again.

"Well," he added, "let me ask you one more thing, has anyone been…*bad*?"

"No!" was the emphatic reply.

"No, of course not!" agreed Santa. "Well, let me get my lovely Snow Queen up here with me," he said. "Come on out, Snow Queen! Here she comes!" he announced as he pointed toward the back of the room.

I made my entrance and took a similar route as Santa, passing tables of attentive children and smiling adults. Eddie Weaver marked my entrance by playing a familiar, lovely Christmas song. Waving to everyone, I walked up the steps of the runway, toward the main stage where Santa awaited. He offered me his hand and helped guide me to the royally set table. He greeted me with "Hi, Snow Queen!" I replied, "Hello, Santa!" Pulling out my chair, he helped seat me as I positioned myself and straightened out my dress.

"Now, how's that, Snow Queen?" he asked as he pushed my chair to the table, making certain that I was comfortable.

"Fine! Thank you, Santa!" I smiled.

"Good!" he said. "But, Snow Queen," he continued, "it looks like we are missing someone! Where is that mischievous little Elf?" he asked as he shaded his eyes with his gloved hand and peered out into the crowd.

I shook my head and looked perplexed, acknowledging that I did not know the answer to his question. Just then Santa said, "Oh there she is," pointing toward the back of the room. "Come on up here, little Elf!" With that command, the Elf skipped between the tables, waving to all. She joined us onstage and took a seat at her own little table.

The Tea Room stage was set with Santa, the Snow Queen and the Elf. No doubt from the audience it looked like a Christmas-laced tableau.

I have to agree with another Snow Queen, Becky Long, who said, "I can't imagine any better job than one where you put on a wedding dress, a tiara, and were paid to eat in the Miller & Rhoads Tea Room!"[51]

After we had joined Santa onstage, the children waited and watched with anxious anticipation for the next treat in store for them…Santa drinking his milk.

Frances Booker Verschuure worked as an Elf and later served as a manager of the Tea Room in the 1980s. "Santa drinking his milk, with sound effects on the organ by Eddie Weaver, was always a crowd pleaser!" she said.[52]

On rare occasions through the years, Santa would receive an added "surprise" when the milk was presented to him. One time the glass

Santa drinks his milk in the Tea Room, 1987. *Santa Charlie Private Collection.*

of milk was double the size it should have been. But Santa drank it all anyway, his expression being even more animated than normal. On another occasion, Santa took a sip of the milk and discovered that it tasted sour (but that was not expressed to the crowd). He improvised and gave the illusion that he "drank it down." He knew that the children wanted to see him drink his milk, and he would not disappoint them.[53]

Susan Scoven was a young child during the 1970s and recalled her visit to the Tea Room. "I remember vividly the lunch with Santa. He spoke to all of us on a microphone and made a large gulping sound drinking his milk that we could all hear," she said. "I remember thinking that eating in the Tea Room was very special. In the following years, having lunch with Santa was not an option; it was 'a must!'"[54]

Santa, the Snow Queen and the Elf enjoyed dining with all the visitors. We were advised by the store to order something from the menu that was appropriate to eat to enable us to wave and smile while eating. Santa had to be careful not to order anything that would fall into his beard; the Snow Queen often wore gloves, so it was not wise to order anything that had to be eaten with the fingers. Also, using a knife and fork looked more "regal"; presenting good manners was important to portray to the children.

As soon as we finished our meal, the highlight for visitors having lunch or dinner with Santa was his serving "Rudolph cake." He explained how Rudolph had helped make the cake. Santa invited the children to get a piece of the cake. "Come on down, Doll Babies!" he shouted.

A cavalcade of children rushed to meet him as he meandered down the runway. He then stepped to the floor level and greeted youngsters as well as some adults accompanying infants and toddlers. Santa distributed the cake at the cake table; it was not unusual to serve over eight hundred pieces of Rudolph cake in a day.[55]

Milton Burke, a longtime employee of the store, recalls the story of the origin of the cake, which became a tradition. "In the early days, in the late 1930s, Santa gave out cake to the children made by 'Mrs. Claus,'" he said. "A group of Catholic ladies had lunch in the Tea Room, but afterward demanded to see Webster Rhoads Sr.," he continued. "Mr. Rhoads received them, and they informed him that

Santa serves Rudolph cake to children in the Tea Room, 1988. *Santa Charlie Private Collection.*

the cake given out to the children could not be referred to as 'that made by Mrs. Claus, because St. Nicholas was not married!' The next day," Burke added, "Santa was instructed by the store to refer to the cake as 'Rudolph cake,' and it stuck!" he laughed.[56]

Mary McNeil shared that her favorite Tea Room memory is in regards to Santa preparing to distribute the Rudolph cake. She wrote:

> *My mother, Dora Delano and I were taking her granddaughter [my niece], Kelly Evington, to have lunch with the Miller & Rhoads Santa. It was December, 1983 and Kelly was almost 4 years old. She was very sweet, prissy and a bit precocious...*
>
> *Santa told the children of the Reindeer Cake that awaited them for dessert. Santa explained how Rudolph, himself, had made the cake for the children. With that, Kelly squealed, "EEEEEWWWWW! I hope he washed his paws first!" With that, the room erupted in laughter! My mother and I didn't know whether to be proud of her hygiene habits or mortified that she thought of Rudolph's dirty hooves!*[57]

Santa served the cake as the tune of "Rudolph, the Red-Nosed Reindeer" was played on the organ by the multitalented and revered Eddie Weaver.

In the 1970s, when I first began playing the Snow Queen, I was asked to perform with the "Santa Party," which was offered as a separate event in the Tea Room on Saturday afternoons. Eddie Weaver discovered that I enjoyed singing professionally. He and Ken Allen, who was in charge of Santaland and its extended activities, asked me if I would like to sing some Christmas songs as part of the party's entertainment. A few years later, Theatre IV was hired to help host the parties, and I continued to appear with Santa and perform some songs. Another renowned Richmond musician, Charlie Wakefield, usually accompanied us on his accordion.

Occasionally, Eddie Weaver would ask me to sing during lunch and dinner when I joined Santa in the Tea Room. If the crowd seemed to be the right receptive group in Weaver's eyes, from his seat at the organ near the stage, he would say, "Queenie, how about singing a song!" I would give him an affirmative nod, and as I rose from my chair, he would confirm with me, in a whisper, the key of the tune. Approaching the microphone, I would sing an appropriate Christmas melody. It was always a thrill for me to have someone in the Tea Room audience send a message requesting a song from me. Several Christmas seasons, my friend Jennifer Orcutt Lueders and her young son Nick would sit near the stage and ask, "Would the Snow Queen please sing us a song?"

I was never offered any extra compensation to sing. It was worth it to me just to have the opportunity to be accompanied by the great Eddie Weaver!

It was a disappointment when, in the early 1980s, I was informed by the store management that "Snow Queens don't sing." With an expansion of the Santaland operation adding more Snow Queens, it was decided that if all Snow Queens could not sing during the lunches or dinners with Santa, then I would not be allowed to do so either. It seems that they desired a consistency in the presentation, and I was the only "Singing Snow Queen."

Eddie Weaver appeared upset for me, as he felt that any talent to improve a performance or "the gig" should be embraced. He

Snow Queen Donna Deekens sings in the Tea Room, 1980. *Bill and Donna Deekens Private Collection.*

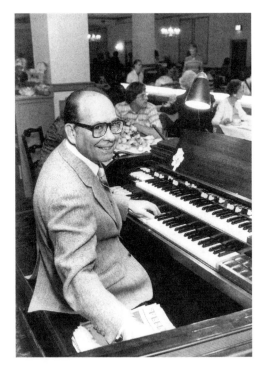

Eddie Weaver at the Tea Room organ, 1980. He was a legend, playing the organ at Miller & Rhoads for more than forty years. His music was a special treat at Christmas. *Courtesy* Richmond Times-Dispatch.

consoled me onstage during one of his breaks, placing his hand on my shoulder and saying, "Don't worry, Honey…there will always be another show!" This is some of the best advice I have ever received, and I took it to heart as words of inspiration for life.[58] But there were times when he would let me sing anyway, and I was always happy to oblige. I felt he had tenure and did not have to worry about being fired for allowing me to sing a Christmas song. When it came to the entertainment for the Tea Room, Eddie Weaver was the master at the controls at Christmas, as well as anytime of the year.

I thought he was the consummate entertainer—a true professional and extremely talented, but never pretentious.[59] I remember how he played most of the music by memory, especially in his later years, when his eyesight was diminishing. Specifically, I recall noticing how youthful his hands and fingers appeared, even when he was in his seventies and eighties. It was an honor and a privilege for me to have had the experience to sing with this organ master. Sometimes his daughter, Jody Weaver, would join us with her accompaniment on the piano—a double treat for me!

For more than forty years in the Tea Room, Eddie Weaver entertained and was considered a legend. He made two long-playing albums that were promoted by M&R. A special Christmas collaboration with Santa was recorded on tape and produced as cassette tapes in 1985.

When Miller & Rhoads closed in 1990, the Santaland operation moved across the street to Thalhimers. Weaver went along and stayed until that store closed in 1992. During many of those years, he was also the organist at the Loew's Theatre at Sixth and Grace Streets, located directly across the street from M&R. Daughter Jody said, "He ran back and forth for a long time."[60] I remember him telling me, in his always engaging manner, about literally running across Grace Street on several occasions to "make his gig" on time, either at the Tea Room or at the Loew's.

Eddie Weaver had a long list of admirers, especially those who worked with him and shared his love of entertainment. Debby Robertson and her sister, Carolyn Mattox, recalled how their dad, Frank Porter, a Richmond radio personality of the 1950s, would have Weaver on his show on WTVR and WLEE. "Eddie Weaver,

Organist Eddie Weaver performs at Richmond's Loew's Theatre with local deejay and entertainer Frank Porter, circa 1950. *Carolyn Mattox and Debby Robertson Private Collection.*

in turn, would have Dad perform with him at the Loew's Theatre," said Mrs. Robertson. "Dad had a talent of whistling on stage as Eddie played the organ." Of course, like everyone else in town, Mrs. Robertson and Mrs. Mattox enjoyed seeing Weaver not only at the Tea Room and the Loew's but at the Byrd Theatre as well.[61]

Whether playing the "Mighty Wurlitzer" for moviegoers at the Richmond theatres or the Tea Room organ for the holidays and such events as white-gloved ladies' luncheons or the businessmen's luncheon meetings, Weaver was a master of the instrument. By pushing buttons and levers, he could make it sound like a harp, a piano, drums—you name it.[62]

At Christmastime in the Tea Room, Weaver enjoyed accompanying the models as they presented fashions representative of that festive time of year. Many of the models made a return appearance only during the holidays so that they could once again walk the runway with Santa when Weaver was at the organ.[63]

Another treat at Christmas that delighted diners at the Tea Room occurred when Weaver played "Jingle Bells" while accompanying Santa. The jolly ole' elf jingled his bells on his belt in "solo" fashion while he was seated onstage.

Eddie Weaver was an asset to Santa in other ways as well. He thoroughly enjoyed helping to make a child's dining experience even

more special by learning the names of the children and "magically" relaying the information to Santa.

Geri Oliver wrote of her daughter's visit during the 1970s:

> *Beth loved Santa but would not sit on his lap. Her thrill was to eat in the Tea Room, watch Santa from a distance and be ever so nice to Santa when she got her slice of Reindeer Cake.*
>
> *She was getting to the age when others were telling her there was "no Santa" when she had the Christmas thrill of her life. We had just moved to a new house and she had her first dog. She eagerly told these things to Eddie Weaver as he walked around during his break.*
>
> *A little later my mother and I cried joyful tears when Santa looked right at Beth and said, "Hi Beth! How do you like your new home and how is your new dog, Sparky?" Beth believed in Santa several more years because of that experience!*[64]

Everyone seemed to love the idea of spreading the Christmas spirit, and the Tea Room wait staff often relished playing the roles of "elves" themselves where children were concerned.

Beth Oliver waits for Santa's arrival for lunch in the beautifully decorated Tea Room, 1974. *Geri Oliver Private Collection.*

109

Penny Mize relayed a favorite visit as she wrote:

> *The Christmas of 1974, when my daughter was almost five, we went with another mother and her little girl to have lunch with Santa at the lovely Tea Room and have our yearly visit with him.*
>
> *While we were waiting for the two of you to arrive for your own lunches, a very nice waitress came to our table to take our orders and to chat for a minute. She asked the girls what their names were and what they wanted for Christmas that year.*
>
> *While we were eating and chatting, you both arrived and sat down. The girls thought you were so pretty and so lucky to be able to see so much of Santa all year!*
>
> *Shortly thereafter, Santa turned in our direction, looking directly at the girls and said in his booming voice with a huge smile on his face, "Why Lisa* [my daughter] *and Claire, how wonderful you could come and have lunch with old Santa today!"*
>
> *Needless to say we were all thrilled!*
>
> *My daughter, who turned forty last February, still recalls that day. It is one of her treasured childhood memories.*[65]

Karen Grady agreed that the Tea Room wait staff made an impression on her as a child when she visited at Christmas with her Aunt Gayle and Great-Aunt Audrey. "They were always very friendly, and I remember one time I wanted to write our waitress a thank-you note for all her hard work," said Ms. Grady. "The entire dining experience was so special and everything seemed so formal and sophisticated, which made me feel so grown up!"[66]

Whether you were a grownup or a child, excitement and anticipation were evident throughout the Tea Room at Christmas. Often a child was so excited that the dreaded "accident" would happen to soil a special holiday outfit. Such was the case when my sister, Judy Jones, and my mother and dad, Evelyn and Mike Strother, brought my little niece, Amy, and young nephew, Michael, for a visit in 1982. They had already been to see us in Santaland. Afterward, they joined us for lunch in the Tea Room. Amy, about two years old, became so excited that she threw up on her new red velvet dress. When they arrived back at Grandma and Grandpa's

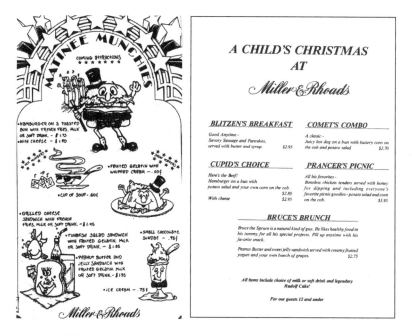

Above, left: Children's Tea Room Christmas Menu, circa 1979. *Bill and Donna Deekens Private Collection.*

Above, right: Children's Tea Room Christmas Menu, circa 1989. *Bill and Donna Deekens Private Collection.*

house in Richmond, where they were staying while visiting from Virginia Beach, Grandma dutifully washed out the dress. She hung it outside to dry and, unfortunately, due to the winter cold, the dress froze and never could be worn again. The "urped-on dress that froze stiff as a board" is a memorable family Christmas story. It continues to be told every holiday season, eliciting grand laughter again from us all.

It was always a thrill in the Tea Room to witness both children and adults become recipients of *the magic*, especially when they least expected it. Janet Spears Hester, the goddaughter of Milton and Bertha Burke, was ten when she visited Santa and was experiencing what we in Santaland referred to as "the iffy stage" of believing. She visited the Tea Room with her godparents to dine with Santa and the Snow Queen before they went to Santaland. As Santa

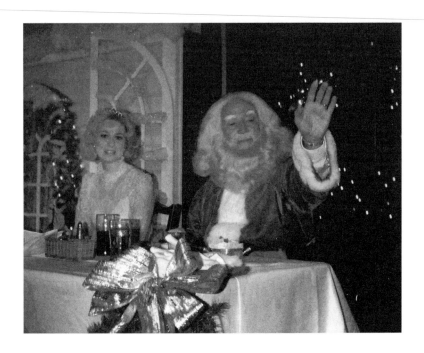

CHRISTMAS IN M&R'S TEA ROOM
It's time for Santa and sleigh bells!
TEA ROOM SCHEDULE
NOV. 24TH THRU DEC. 24TH

Friday, Nov. 24th	Serving 9:00 a.m. to 2:30 p.m. Santa in Tea Room 9:45 a.m. to 1:45 p.m. Serving 4:30 to 6:30 p.m. Santa in Tea Room 5:00 to 6:00 p.m.
Saturday, Nov. 25th Dec. 2nd, 9th, 16th & 23rd	Serving 9:00 a.m. to 2:30 p.m. Santa in Tea Room 9:45 a.m. to 1:45 p.m.
Sunday, Nov. 26th Dec. 3rd, 10th, 17th & 24th	Serving 11:30 a.m. to 2:30 p.m. Santa in Tea Room 12:15 to 2:00 p.m.
Monday thru Friday	Serving 10:30 a.m. to 2:30 p.m. Santa in Tea Room 11:00 a.m. to 1:45 p.m. Serving 4:30 to 6:30 p.m. Santa in Tea Room 5:00 to 6:00 p.m.

SANTA'S SATURDAY PARTY, TEA ROOM, 4:00 TO 5:00 P.M.

Dec. 2nd, 9th & 16th	Tickets $3.00 per person. Available at Customer Service. M&R Downtown only.

Miller & Rhoads

...Where Christmas is a Legend

Above: Snow Queen Donna Deekens and Santa enjoy lunch in the Tea Room, 1988. *Bill and Donna Deekens Private Collection.*

Left: Miller & Rhoads's Tea Room Schedule, available at the store, 1989. *Bill and Donna Deekens Private Collection.*

walked past the table where they were sitting, he approached the young girl and said, "Why Janet, I didn't know you were going to be here!" Santa smiled and headed for the stage, and Janet said in amazement to her godparents, "How did he know my name?"

"'Santa magic!' was always the correct answer," said Burke, who was an M&R employee at the time, and who confessed he had an "in" with Santa Claus.[67]

When Santa and I were seated on the Tea Room stage, sometimes I would spot folks I would know, but I was certain they did not know me. One such time was a visit from two young women who were acquaintances of my sister. They were from Portsmouth, where we had spent our childhood years. We had heard that one of the gals had moved to Richmond. Of course, they did not recognize me, especially as the Snow Queen. The hostess had seated them appropriately, but not "planned," next to the stage where Santa and I were dining. I recognized the one girl and whispered to Santa, "The girl sitting right in front facing us does not know me, but I know who she is. Her name is Elizabeth and she is from Portsmouth." He nodded affirmatively to me and looked in their direction.

Santa waited a short while, and in perfect timing (he seemed to have a knack for anticipating just the right moment), he pointed to the young woman and waved as he called out, "Elizabeth, are you enjoying your lunch?"

A look of disbelief came over her face as she tried to swallow her food and sheepishly waved back to him. Santa continued the frolic and inquired, "How is everything down in Portsmouth?"

Both young women had the deer-in-the-headlights look. It was obvious that the entire time we were in the Tea Room they were trying to figure out how Santa knew Elizabeth's name and how he knew about Portsmouth. It was "Santa magic," and we loved it!

The Tea Room was a place filled with joy, humor, exuberance and whimsy for all who dined there during the busy Christmas season. The wonders of the Tea Room were made even more memorable because of the love and adoration exuded by the children and adults who were seeking, and perhaps found, the Christmas spirit. Perhaps, too, they were lucky enough to experience, if only for a fleeting moment, *the magic*!

Beyond Santaland

M iller & Rhoads was the focal point where thousands of visitors were drawn to downtown Richmond during the Christmas season, and the magnet was Santa. During the decades of this phenomenal tradition, the store sponsored other in-store attractions as well as off-site events to attract children and adults. These enhancements became destinations themselves and cherished traditions in their own right.

The Miller & Rhoads windows were a big draw for visitors seeking beauty and fantasy all wrapped up in a wonderland behind glass. The train window was a favorite. This was evident by the crowds huddled close to the window to get their best view from different perspectives. These angles could be accomplished since the scene was created in a corner window. The three electric trains running simultaneously on different tracks displayed an impressive array of locomotives pulling passenger and freight cars, painstakingly placed in just the right positions to give the correct feel of depth perception.[68]

The train window scenery included a city where Miller & Rhoads operated a store, which was always identified by an "M&R" sign. Some years the train exhibit highlighted the countryside route of Richmond, Charlottesville and Roanoke. Other Christmases focused on the cities of Charlottesville, Lynchburg, Roanoke and Richmond. One of the most beloved of the train displays was that of the city of Richmond and its downtown skyline.[69]

Train window display featuring Richmond, Charlottesville, Lynchburg and Roanoke. Store locations were noted with an "M&R" sign. *Courtesy Dementi Studios.*

Allen Rhodes, an M&R employee from 1950 to 1968, was in charge of creating the window displays of the trains. Although he was involved with helping to create many store windows and painting wall murals, Rhodes confessed that he spent countless hours on the train windows.[70] "Almost as soon as one Christmas season would end, we would begin planning the train window for the next season," he said. "I would cut out wood pieces to make the buildings, which I would paint."

His creative displays included the unique and rare three-train crossing in the Richmond scene. "It was intricate work, but I had good help," he continued. "The tunnels were made of papier-mâché and had to be wrapped with asbestos sheets on the inside to prevent a fire hazard. We probably could not do that today."

Often the trains would be in the first window, which would catch your eye as you approached the store at the corner of Fifth and Grace Streets. After enjoying the trains, customers could then enter the store from that Fifth and Grace corner door. As the decade of the 1960s rolled on, and even into the 1970s, the train window continued to delight and entertain customers each holiday season.[71]

Other windows that were visual sensations to all throughout the years included the creations by M&R display director Addison

The Madonna window at Miller & Rhoads was a serene display at Christmas, 1971. *Nancy and Ben Emerson Private Collection.*

Lewis. Memorable Lewis-designed windows with religious themes included those such as the Nativity window and the serene Madonna window.[72] Often the Madonna and Child were papier-mâché figurines purchased from New York.[73] The creative design of the windows they occupied was due to Lewis's genius and his talented staff. The displays were admired not only by Richmonders, but also by people who would travel from distant cities to view them. Lewis served as director of the store's displays for more than fifty years, followed by display director John Boulware.[74]

For the store's fifty-four windows, the display directors were fortunate to have creative and extremely talented personnel such as Rhodes. Another valuable employee, Milton Burke, devoted forty-four years to his job, beginning in the 1940s. Burke assisted in all display tasks, especially at Christmas. His creative touches could be seen throughout the store, which included his decorations in Santaland, and his flair also was recognizable in the impressive floor and window displays.

"We worked hard," Burke reminisced, "but one time when things were somewhat slow in my earlier days, I asked Mr. Lewis if one of my colleagues, Edith Martin, and I could go on our lunch hour to see the movie playing around the corner at the Loews Theatre. He said 'Sure!' The feature was *Gone with the Wind*," Burke added, "and we didn't know it was a three-hour movie. That was a long lunch hour. Can you imagine a boss allowing someone to do that today?"[75]

Other display windows presented whimsical themes with toys, dolls and animated figures that produced laughter and delight, especially for children. Creating such memorable windows as the "Enchanted Forest" and the "Angel Orchestra" behind glass, an ethereal glow was cast at night with an impressive backlighting effect.[76] This only helped to heighten the anticipation of Christmas for all who visited downtown.

Inside the store, another popular attraction introduced in the 1980s was "Bruce the Spruce," the talking Christmas tree. "Bruce" was considered "Santa's Tree" and drew almost as many fans as the Miller & Rhoads Christmas sensation of the 1940s and 1950s, "Felix the Clown" (Felix Adler) and his sidekick piglet, Amelia. Bruce

Above, left: Store display windows often featured whimsical themes. These mechanical figures of an elf and a beaver brought delight to visitors of all ages who enjoyed the animated windows each Christmas. *Courtesy Valentine Richmond History Center.*

Above, right: A father and children gaze at M&R's Christmas window display featuring mechanical animals dancing in the snow, circa 1968. *Courtesy* Richmond-Times Dispatch.

was placed in strategic locations such as the children's department on the second floor. There, he would have a captive audience of youngsters.

Eric Verschuure worked in various departments of Miller & Rhoads in the 1980s. In 1983, he expressed an interest to the personnel department that he would like to be Bruce the Spruce for the holidays. He was interviewed by a store executive, who was impressed that Verschuure said he understood he must "think like a tree." According to Verschuure, apparently a few previous Bruce the Spruce characters had made some inappropriate comments to shoppers. Such behavior was not tolerated by the store. So Verschuure was informed that M&R wanted to make certain that the "Bruce" who was hired was a good fit for the position. Verschuure got the job, and he was excited to be given the opportunity. He said that his pay was raised "from $3.35 to $4.00 per hour."[77]

Robert Stowers (left) and Jeffrey Knox visit with "Bruce the Spruce" at Miller & Rhoads, 1989. *Caroline Stowers Private Collection.*

Verschuure said during that particular Christmas season, Bruce was situated between the children's and lingerie departments near the escalator. The tree talked to the young audiences and told them that he was a special visitor to the store for the holiday festivities. He told the story about how he left the forest each Christmas to accompany Santa to Miller & Rhoads.

Bruce was approximately eight to ten feet tall and decorated with brightly colored Christmas ornaments.[78] He had an expressive face located in his center, with large eyes, rosy cheeks and a bow-shaped mouth that moved when he talked.

Verschuure recalled his initial portrayal of Bruce that year:

> *"Black Friday" came* [I do not believe that it was called Black Friday in 1983] *and I crawled into the tree for the first time. It was baptism by fire. I quickly learned how to move Bruce's head and his lips. The first day I worked his lips by pulling the wire barehanded; from then on I wore gloves. Hindsight tells me that sitting on the floor, I would eventually "borrow" a cushion from somewhere and sit on it, and turn Bruce's head and move his lips and hold a microphone, which was demanding enough, but I also had to entertain.*
>
> *I came up with a story that Bruce had been taught to speak by Santa and Mrs. Claus. I would sing for the shoppers and would soon come up with a group of "standards" that I would repeat over and over again. Since I was trying to engage the children who were visiting Bruce and have them sing along with me, I would sing "Frosty the Snowman" and "Rudolph the Red-Nosed Reindeer." I do not recall ever asking anyone if Bruce had sung in prior years. It just seemed the right thing to do at the time.*

By the middle of the Christmas season, Verschuure said that he probably had a usual routine that ran about fifteen minutes. He added that an observer might have been able to figure out when he was running out of material, as he would sing "Happy Birthday." He would ask children when they celebrated their birthdays and then he would simply sing the song as "filler."

Initially, Verschuure was assigned to portray Bruce five days a week. He said that stretches of being inside the tree for thirty minutes to longer than ninety minutes at a time would comprise a 10:00 a.m. to 5:15 p.m. workday. "Since it was a difficult task to get in and out of the tree, often longer stretches with less going in and out were preferred," he added.

Verschuure elaborated:

> *I recall that the most difficult thing about being the tree was getting in and out of it unobserved. I usually wore my gloves and carried a trash can when trying to get in the tree. The shoppers would not pay any attention and would look at the tree and not me. Then I would get down and almost leap into the tree. Getting out was equally as challenging. Bruce would have to "take a nap" periodically. But if the crowd had just gotten there, they wanted to wait around for the next "show." I recall a number of times not being able to get out of the tree for five to ten minutes, fearing I would ruin the illusion for someone.*

Verschuure said that being Bruce the Spruce was "quite rewarding." In addition, he enjoyed being asked to help train personnel who were hired as Bruce for subsequent holidays. "I was pleased to see a lot of my notes and lyrics to songs still taped in the tree during the 1989 Christmas season," he said.[79]

An added benefit of Verschuure playing Bruce the Spruce was meeting his wife, Frances Booker Verschuure. She had been one of Santa's elves the year before. In 1983, she received a promotion and managed the Tea Room, assisting food services manager Sally Dunn and Store Executive George Bryson. "I enjoyed the crowds in the Tea Room from a different perspective than playing an Elf," Mrs. Verschuure said.[80]

She explained that the new position afforded her the opportunity to move about the store more during that particular Christmas. In doing so, she visited the children's department a few times and observed a "character" in the store, Bruce the Spruce.

"I can't say it was love at first sight, because I couldn't even see the guy who was inside that tree!" she laughed. "But I could hear his

voice, and I knew I had to meet him! We became great friends, kept in touch and twenty-five years after that first Christmas together at Miller & Rhoads, we were married."

Bruce the Spruce also was entertaining to watch in the Santaland videos, which were offered to visitors in the late 1980s. Parents could purchase the eight-minute VCR tape, which often featured Bruce, Santa, the Snow Queen and the Elf in an original Christmas story with music. A new Santa story was introduced each season.

When the Santa operation made the move to Thalhimers in 1990, Theatre IV characters were added to the video's cast, along with the loveable "Snow Bear." The tape included a child's personal visit with Santa tagged at the end. I was fortunate to be the Snow Queen in several of those video vignettes. This was especially meaningful for me in 1990, when I appeared in the video and my two little boys' visit was tagged onto the ending.

In addition to seeing Bruce, one of the most enjoyable of the attractions for the children at M&R was a visit to the Fawn Shop. Also located near the children's department, the pint-size store was "for children only," except for the store employees who helped youngsters with their purchases. The entire atmosphere and ambiance catered to the children. The curved bridge leading to the child-size entrance was inviting, and often there was a waiting line. Even the display counters were smaller than normal. The items for sale were for a child's budget, too, as everything was priced usually less than one dollar.[81] Fawn Shop "helpers" were informed by parents what the child was allowed regarding a spending budget. Merchandise that was offered included soaps, perfumes, scarves, pens, pencils, ties, socks, candy and knickknacks.[82] Parents and friends patiently waited for their children while they shopped. Indeed, it was a proud moment for a child to shop for Christmas presents for Mom and Dad, and do it "all by myself!"

Laurie Evans Pancer remembered her visits to the Fawn Shop in the 1970s. She recalled that her family would make a point to go there after lunch in the Tea Room.

"Store employees would escort us in while our parents waited outside," Mrs. Pancer said. "They would assist us in buying trinkets

Tripp (left) and Neal Metzger enter the Fawn Shop for children at Miller & Rhoads, 1989. *Lynette and Clyde Metzger Private Collection.*

for those on our gift list. I remember buying my grandmother a brush that you filled with soap to wash the dishes!" she noted. "After we finished we were so proud of our purchases and could hardly keep them a secret!"[83]

Outside the store, one of the most popular events was the Miller & Rhoads "Santa Claus Train," which ran from 1958 to 1971. During the Christmas season, it ran four times each Saturday, leaving Broad Street Station. The destination was north to Ashland, about sixteen miles away, and then back to Richmond. One thousand children and five hundred adults were onboard for each trip. It was important to book early, as each trip usually sold out. [84]

I had the pleasure of being the Snow Queen with Santa for this special excursion only on one Saturday in 1971, the last year of its run. By that time, tickets sold for four dollars each, which was a change since the early days when tickets went for fifty cents apiece.[85]

I remember Santa and I walked from car to car, waving to all and greeting children and their parents. We tried to acknowledge everyone, which was great fun but sometimes challenging. Most children got a pat on the head from Santa. The truly lucky little ones were picked up and held by him. Local musician Charlie Wakefield accompanied us and entertained by playing his accordion. In addition, Miller & Rhoads Teen Board representatives helped monitor the crowd and distributed candy canes.

It was a thrilling, magical event. The children were told that they were going to the North Pole to see Santa. Looking back on it, I think of it now as the original "Polar Express."

Mary Louise Stewart Johnson was a Snow Queen from 1965 to 1968 and experienced many Santa Train trips. As a member of the M&R Teen Board, she learned that a Snow Queen position was available. "I absolutely loved it!" said Mrs. Johnson. "I loved working with Santa, and we especially had fun on the Santa Train."[86] She recalled making those trips:

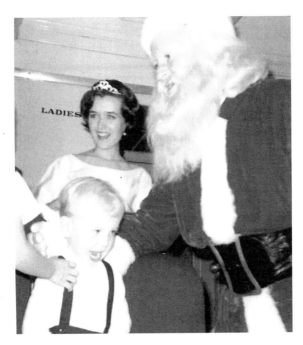

Snow Queen Mary Louise Johnson and nephew Aubry Stewart with Santa on the Santa Train, 1966. *Mary Louise Johnson Private Collection.*

Santa and I would be picked up from the store, in costume, by a limousine, and we were taken to Ashland. He and I stood by the railroad tracks near Randolph-Macon College and the train stopped and we got aboard.

After the train left Ashland, we traveled north to Doswell, where the locomotive was turned around so we could go south. We headed back to Richmond and arrived at Broad Street Station. The children and adults left the train, but Santa and I waved to them from a platform in the station, which held a sign telling everyone to visit Santa at Miller & Rhoads.

A second group of visitors would board the train. Santa and I were taken back to Ashland, where we would once again wait for the train's arrival. This scenario was repeated four times each Saturday. I made fifteen dollars for each trip, which totaled sixty dollars for a day's work. That was really good pay for a young girl in those days!

It was all so wonderful! I remember one time the train was longer than usual. We walked through twenty-two cars and I vividly remember my face hurting because of all the smiling I had to do!

Mrs. Johnson recalled that during one of the Santa Train trips, she remembered she and Santa were sitting in the parked limousine in Ashland, waiting for the train to arrive. They were enjoying a box lunch and heard a tap at the window. A little girl of about ten years old was standing by the impressive car and saw Santa and the Snow Queen sitting together in the back seat. According to Mrs. Johnson, the little girl, who did not appear to be chaperoned, peered into the vehicle. Looking perplexed, she asked, "Santa Claus, who is that with you?"

"Why, this is my lovely Snow Queen," Santa replied.

"Why, Santa Claus! You rascal, you!" she exclaimed.

Sadly, the Santa Train trips ended in 1971 when the National Railroad Passenger Corporation (Amtrak) took over the Richmond, Fredericksburg & Potomac line. The new operation resulted in not being able to provide enough passenger cars to carry the crowds.

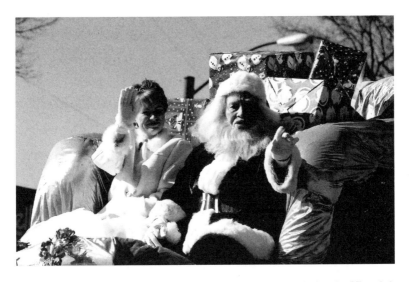

Santa and Snow Queen Christy Miller acknowledge greeters during the Ukrop's/ Retail Merchants Association of Greater Richmond Christmas Parade, 2004. *Santa Charlie Private Collection.*

More than 100,000 people had enjoyed the holiday excursions during its long run.[87]

Santa lived up to his reputation of being "everywhere" through the years, and not just on the Santa Train or at the store. Among his appearances, he lit the Christmas tree at the Virginia State Capitol and the Jefferson Hotel. He could be seen visiting the children's ward at the Medical College of Virginia and also the Children's Hospital. Often, Santa appeared at Christmas parties at the Virginia Home for Adults.[88] He hosted the kickoff red kettle campaign for the Salvation Army in the 1980s, as well as appearing at the Salvation Army Toy Center.

Santa enjoyed being the grand marshal for numerous seasonal parades, including the National Tobacco Festival Parade in Richmond, which ended in 1984. More recently, he appeared in the Jaycees Parade, which became the Ukrop's/Retail Merchants Association of Greater Richmond Christmas Parade. Today, it is the Ukrop's-Supervalu Richmond Christmas Parade.[89] Always, his

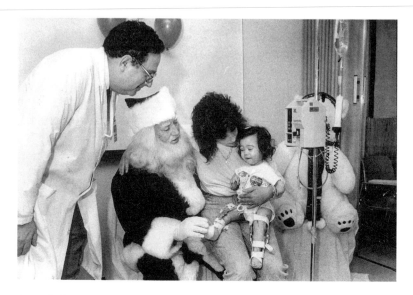

Amanda Dudley, fourteen months, was visited by Santa at MCV, 1986. Mother Kim Dudley and Dr. Harold Maurer also were present. *Courtesy* Richmond Times-Dispatch.

Santa visits with Lillian Benstead, fifteen months, during a Santa and Snow Queen Christmas party benefitting the Salvation Army, 2008. *Heidi and Jon Benstead Private Collection.*

appearances have created a multitude of smiles from onlookers along the route.

The spirit of giving resonated in many ways from Miller & Rhoads to wide-reaching audiences who embraced that love and goodwill. The effects of those attractions, beyond Santaland, still sparkle and conjure up in our memories those extraordinary times we choose to cherish.

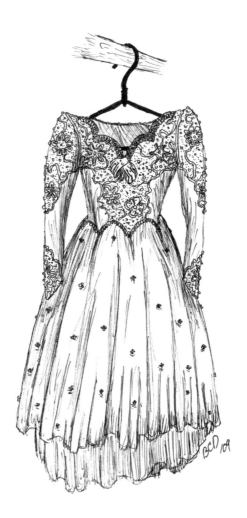

Weary Santa, Tired Snow Queens, Grumpy Elves

It was a common occurrence on a busy Saturday for as many as 750 children to make their way through the line to visit with the Miller & Rhoads Santa, Snow Queen and Elf. Often the crowd was so loud with happy voices that it was difficult to even hear Santa speak. He would talk into a microphone while visiting with a child on his lap and inquire about his or her wish list, but sometimes his words were masked by the visitors' mere excitement.

During those engaged times, Santa was careful to keep a rhythm. He knew to pace each child or group of children, but he was mindful not to rush any visit. He was sensitive to the fact that each visit was special for each child. Santa knew that every little visitor had come to see him and his helpers in Santaland. He wanted to make certain that their visit was worth the long and sometimes tiring wait and effort invested by both children and adults.

Busy days and nights produced a few frustrations for some Santaland employees at various times. The Snow Queens experienced those moments just as any of Santa's assistants sometimes did, but they always were expected to present themselves as elegant and in control.

In my case, I remember that it was important to smile sometimes when I did not feel like smiling and, of course, refrain from showing any unpleasantness or frustration in my facial expressions. At times my hands tired from waving, and sometimes I wished that I could

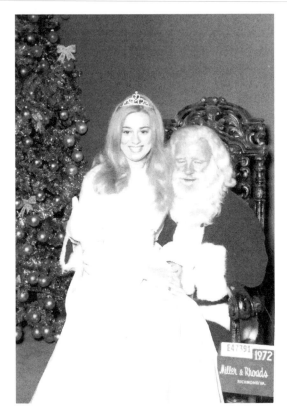

Santa and Snow
Queen Donna
Deekens, 1972. *Bill
and Donna Deekens
Private Collection.*

be like a puppet and simply pull a string for my hands to alternate
the motion. Nevertheless, the joy of greeting everyone was part of
the fun of the job.

The Snow Queen was the primary greeter to each child before
he or she visited with Santa, and we were aware of this important
responsibility. Most of the time, talking with the children and
carrying on conversations with them just before they went up to see
Santa ran very smoothly. It was a thrill to witness all the little ones
dressed in their best attire and anxious to talk with me and then
Santa Claus.

As the Snow Queen, my initial greeting and the exchanges with
the children went off quite well most of the time. One year, however,
a little boy of about five years old came up to me and immediately I
attempted to strike up a conversation with him.

"Hi, what's your name?" I inquired. There was no response and no eye contact made to me by him.

I asked him again. "Hi, can you tell me your name?" Once more, there was no response from the little fellow.

I kept asking him, "What's your name? I know you must have a name!" But he kept looking down at his shoes and shuffling his feet, refusing to make eye contact with me. He simply was determined that he would not be talkative that day, at least to a Snow Queen.

I continued to try to pry his name out of him. "Santa is about ready to talk with you, and I would like to know your name," I said, feeling somewhat nervous that the previous child with Santa already had completed her visit. Santa looked inquisitively toward us, and one more time I quietly pleaded, "Please, tell me your name!"

No doubt tiring of my constant bombardment of asking who he was, he finally said, "Johnny!" looking away from me as he announced it reluctantly, but quickly.

I breathed a sigh of relief, trying to still look "queenly," and said, "Okay Johnny, Santa is ready to see you now!"

"Hi, Johnny!" Santa called. "Come on over!"

Johnny walked slowly toward Santa and gingerly climbed on his lap. Santa greeted him and said, "Let's have a smile for a picture, so look right there," pointing to the stationary camera. Johnny smiled a half-smile, and his photograph immediately was taken.

"Fine! That was a good one!" Santa commented, attempting to begin his conversation with the little boy. But Johnny was not very talkative to Santa either. In a soft, shy voice, the youngster told him only a few things that he would like to have for Christmas.

"Well, Johnny," said Santa, "I'll see what I can do, and I'll try to put some surprises under your Christmas tree, too. Now you be good, and I'll be coming by, and remember ole' Santa loves you!" With that affirmation, Santa eased Johnny out of his lap, gently placed him on the Santaland stage floor and pointed him in the direction of his mother. She was waiting for him to join her at the end of the ramp that exited down from the stage. Radiant with a big smile, she was glowing with obvious excitement for her son's arrival.

As Johnny maneuvered down the ramp, a Santaland employee who was monitoring the line waiting to see Santa overheard the

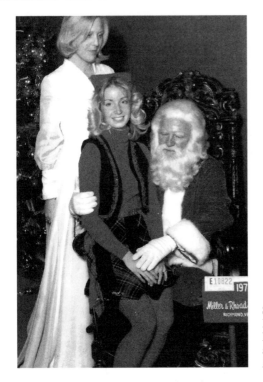

Snow Queen Beverly Edwards, Elf Ann Dickinson and Santa pose at Santaland, 1976. *Beverly Edwards Private Collection.*

conversation between Johnny and his mom: "Oh, Johnny, Johnny, isn't that wonderful…Santa Claus knew your name!" she exclaimed.

"Yeh," replied Johnny, "but that damn dumb fairy didn't!"

Often I have wondered how many other children thought of the Snow Queen as the "damn dumb fairy" because she was so persistent sometimes in asking their name. The "Johnny" story, or the "DDF" story, as my husband calls it, has been a great source of laughter for me, my family and friends every time it is told.

Santa's popular "Little Elf" was not immune from frustrations either, according to Ann Holt Dickinson, who began working as an Elf at the age of fifteen.[90] She remembered:

> *I had to get a work permit because I was not yet sixteen years old when I started. It was a great Christmas job, and I enjoyed it immensely, except perhaps for the times I had to coordinate snapping the photo of a child who did not want to cooperate*

with Santa. In the early years, when I began working in 1971, there was no photographer on duty to actually take the picture, so the Elf would snap the photograph. I remember I had to make sure we were getting the photo at the right moment, which was sometimes a challenge.

Mrs. Dickinson tried the Snow Queen role on a few occasions, but that job did not work out as well for her. "The dresses just didn't seem to fit me properly," she said, which proved to be a handicap to her "connection" with Santa. "I really preferred being an Elf."

Her sister, Amy Holt Davis, also became an Elf at M&R and worked for many years during the holidays as well.

Mrs. Dickinson enjoyed the role of Elf so much that she worked during her Christmas vacations throughout high school and also during her college years at the University of Richmond. After she married, she continued as "the mischievous little Elf," the endearing term Santa called all his elves, and worked every Christmas until the birth of her daughter, Abby. When little Abby became a young lady, she carried on the tradition and worked as a Snow Queen for Santaland in 2003.

The working days and nights for all of Santa's helpers could be very hectic and even taxing. Often as a Snow Queen, I would work on Saturday mornings with Santa in Santaland and then join him for lunch in the Tea Room. On that same day, in the afternoon, I would perform in the Tea Room with Santa and Theatre IV for the Santa Party, which always was sold out. In the late 1970s, although I was working a part-time position as the Snow Queen, I was also working a full-time job with the Valentine Museum. In addition, I was performing a lead role some evenings in a regional dinner theatre production. I was carrying a full schedule, and I felt as if I was running on overdrive. I have been told that I function better when I push my limits, and perhaps that is true. At any rate, I know that I made it through those frenzied times with the help of my patient and very supportive husband, Bill.

One Saturday during that heavily laden time, I must have looked less like a Snow Queen and more like a "Snow Flake." I consciously continued to remember to smile, trying hard not to allow my fatigue

Santa and Snow Queen Donna Deekens on stage at Thalhimers, 1990. Organist Eddie Weaver and his daughter Jody provided accompaniment. *Bill and Donna Deekens Private Collection.*

to show. During my appearance in the Tea Room for lunch, my mom and dad stopped in to eat with us while Christmas shopping. Organist Eddie Weaver spoke to my parents and commented to them that I looked "extremely tired" that day. My mom replied, "I guess she does. She is burning the candle at both ends!"

Nevertheless, I always seemed to be invigorated by the children. Seeing them smile and wave was an inspiration to even the most weary of Santa's helpers, and I am sure that the same was true for Santa himself. The smiles, waves and kisses blown to us were infectious. We loved to reciprocate, and such symbols of affection kept us going.

Santa had the busiest and most demanding schedule of all (especially topped off with his Christmas Eve trip). It was important for

Miller & Rhoads Holiday Gift Guide front cover, 1987. *Dan Rowe Private Collection.*

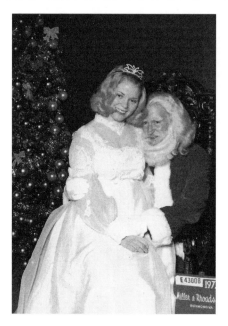

Snow Queen Carol Schlichtherle and Santa, 1972. *Carol Schlichtherle Private Collection.*

him to stay healthy. However, one year Santa developed a bad case of laryngitis. He made his entrance in the Tea Room at lunchtime, greeted the children with a raspy voice and tried his best to introduce the Snow Queen and the Elf.

Carol Schlichtherle, the Snow Queen dining with Santa that day, said that Santa then stepped up to the microphone on stage, as was his usual routine, and began to show the audience how he drinks his milk. The glass of milk was presented to him, and he attempted to offer his famous piece of advice: "Boys and girls, remember to drink all of your milk! But don't drink it like I do, or you might get a little tummy ache!" said Mrs. Schlichtherle, quoting Santa.[91] She continued:

> *It was obvious his voice was hoarse and in bad shape. But a medical doctor was in the Tea Room having lunch with his family, and the doctor sent a note to Santa by way of Eddie Weaver. Santa read the note, which was an offer from the "Doc" to examine Santa's throat right there in the Tea Room! Santa made an announcement to the audience in his unrecognizable voice, which was breaking up, that he was going to check on the reindeer. Then he went behind the stage, and the doctor was escorted to meet with Santa there, where he examined his throat and wrote out a prescription for him right there on the spot!*

Mrs. Schlichtherle said that Ken Allen, the head of the Santaland operation at the time, immediately dispatched someone from Miller & Rhoads to go to a nearby drugstore to fill the prescription.

"Within the hour, Santa had taken the medication," she said. "He soon began to feel better and regained his voice in a short time, thanks to the good doctor who offered his services. I understand the doctor's son was quite impressed that his dad had helped to cure Santa!" she laughed. "But," she added, "you know no doctor would be able to do that in this day and age!"[92]

Santa and his helpers were fortunate to have the M&R infirmary located directly next to Santaland, which came in handy if someone was feeling ill or needed a rest. It resembled a small hospital ward, with white beds in a row and a nurse on duty.

Whenever Santa could find time to take a break—even for fifteen minutes—he would lie down on top of one of the beds and take a nap, still dressed in his red suit and boots. Any of Santa's helpers had the opportunity to rest if needed, but those opportunities were rare. I remember that I took advantage of a short rest only one time in the infirmary, lying down on the inviting bed in my complete Snow Queen regalia. This turned out not to be a good idea due to my elaborate attire, even for a catnap.

Other store elves, the employees of Santaland, were dedicated and conscientious to see that the operation ran smoothly. However, as with any production—even a "magical one"—on occasion, nerves were heightened, tempers sometimes flared and things did not go off as planned.

In the early 1970s, a major problem arose with the photographs taken of Santa and the children. In those days, a photographer was employed to take the posed pictures. This was the pre-digital age of film cameras, and only one camera was used. A photographer was not always on duty to monitor the operation. In those days, one of the Elf's responsibilities was to press a button to snap the picture.

Unfortunately, on a very busy day after Thanksgiving, the lens cap mistakingly stayed on the camera all day. Many photographs were taken, as that was a day when hundreds of folks came from out of town. There were no photographs for that day, and many disappointed visitors. They were offered the chance to come back

and get a complimentary picture taken again with Santa, with no waiting in line. This was convenient for the children and their families who were in the metropolitan Richmond area. However, for visitors who lived a good distance from central Virginia and were in town for that one day, they would have to wait until the next Christmas for their traditional picture with Santa. (All photographs had to be taken by December 8 in order to be delivered in time for Christmas.)[93]

Another mishap with the camera also occurred in the late 1970s, according to Laney Caston of Caston Studios, who eventually took over the photography operation for Santaland. Caston recalled:

> *The previous photographer had a problem with his camera and it malfunctioned for three days, missing numerous photographs and upsetting many visitors and store personnel. We came in and installed three specifically designed cameras that would take the picture at exactly the same time. If one camera went down, or sometimes the film had to be changed, the other camera would get the shot.*[94]

Caston said that other improvements in the operation were instituted in the 1980s. "We went digital when digital really started being digital," he added. "The first two years we used one digital camera and two film cameras, then eventually all digital."

According to Caston, he and one of his photographers, the late John Broadwater, developed their own system for the cameras to operate efficiently and successfully to take the pictures for Santaland. "Macy's in New York was so impressed with our operation they sent down twelve store executives to Miller & Rhoads to observe us and how it all worked," he said. "We continued the operation at Thalhimers as well."

One of the most upsetting instances that had everyone in Santaland feeling low occurred during the beginning of the 1979 holiday season. We all reported to work the day after Thanksgiving, only to discover that the beautiful wooden antique chair, from which Santa had greeted visitors for decades, was missing! We heard that sometime between the previous Christmas and setting up for the

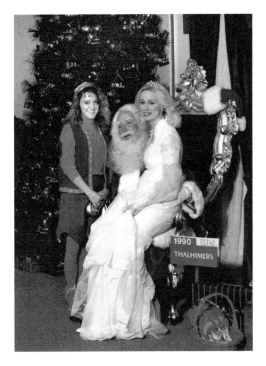

Snow Queen Donna Deekens and the Elf share a light moment with Santa in Santaland at Thalhimers, 1990. *Santa Charlie Private Collection.*

new season, the chair had disappeared. It was not known what had happened to it between storage (usually at a nearby warehouse) and the store. We were all crushed, as this was a piece of memorabilia that could not be replaced. Santa was heartbroken.

The store dispatched a low-back chair from the furniture department that was used that year, but it did not work well. When the 1980 holiday season rolled around, a new Santa chair was placed on stage in Santaland. The ornate, green-cushioned chair, gilded in gold scrolls, proved to be a beautiful throne for Santa. It was used throughout the remaining years at Miller & Rhoads and Thalhimers, and continues to be used at the Children's Museum.

The location of the antique chair and the mystery surrounding its disappearance remains unsolved. Santa confessed to me that he thinks he knows what happened to it and its whereabouts, but cannot prove it. It is sad to imagine that such a piece of Richmond history perhaps is hidden in someone's home or attic. It should be at the Children's Museum or the Valentine

Elf Janet Pritchett stops on the Tea Room runway to greet a young admirer having lunch with her, Santa and the Snow Queen, 1988. *Janet Pritchett Private Collection.*

Richmond History Center for everyone to enjoy. Hopefully, it will resurface one day.

There were issues that would arise backstage at Santaland, too. One ongoing concern involved how often the Santa outfits and Snow Queen dresses would be cleaned. Regarding the dresses in particular, the white train became almost black from dragging on the floor. Also, with different young ladies wearing the same dresses, more frequent cleanings were requested (even though a Snow Queen commented one time, "Snow Queens don't sweat, we glisten!"). Once in a while, notes could be found pinned to a Snow Queen dress: "Please have me cleaned!" The request would be made but not always responded to in a timely manner. Santa's suits took precedence, which was understandable.[95]

Also, when repairs had to be performed on the Snow Queen dresses, action to correct this did not always seem to be a priority,

either. Carol Schlichtherle recalled the time a piece of lace was loose on the train of the dress she often wore. She was fearful that it could be a hazard, for it had the potential to catch on something whenever she had to walk while wearing it.[96]

"I need to have this fixed," she told the person in charge of maintaining the Santaland costumes. "But other issues must have been going on involving Santa's outfits, and they certainly were more important, so my dress didn't get fixed right away," she said.

"Sure enough, while going up the steps of the stage of the Tea Room," Mrs. Schlichtherle continued, "the loose lace caught on the edge of one step, and I almost tripped. I remember hearing cries from folks seated at tables near the Tea Room stage, 'Oh no, she's going down,' but luckily, I caught myself in time and regained my regal stance, and Santa and the Elf and I enjoyed our lunch on stage after all!

With so many store personnel carrying out various tasks in the day-to-day workings of Santaland, the Tea Room, the Christmas windows and other holiday displays, the Fawn Shop, "Bruce the Spruce" and, on Saturdays, the Santa Party—not to mention the sometimes frenzied Christmas sales—it was remarkable how efficiently and, indeed, magically the Christmas season functioned at the store.

As with all detail-oriented events, problems were encountered. Yet the enchanting, almost mystical vision that was created not only helped us to tackle any difficulties, but ultimately overcome them, evoking the best of the holidays and inspiring us to spread the Christmas spirit.

The loyalty, dedication and hard work of all those involved ensured that Santa's appearance at Miller & Rhoads every year kept true to the commitment of excellence and traditions everyone came to expect from the store. After all, at that special time of year, Miller & Rhoads was *the* place to be: "*Where Christmas Is a Legend.*"

The Era of Stardust

And now the purple dust of twilight time
Steals across the meadows of my heart
High up in the sky the little stars climb
Always reminding me that we're apart

You wander down the lane and far away
Leaving me a song that will not die
Love is now the stardust of yesterday,
The music of the years gone by.
"Stardust"[97]

My parents' favorite love song, which they considered "their song," was "Stardust." I recently came to the realization when I listened again to its haunting melody and enchanting lyrics that, indeed, it represents a song for lovers. I also realized how some parts of this lovely song appropriately describe the love still felt for Miller & Rhoads and the beautiful Christmases spent there, forever etched in our memories.

I remember the last day I worked as a Snow Queen at Miller & Rhoads. I'll never forget the veil of sadness that came over me. I did not work on Christmas Eve of the last season at the store in 1989. I elected not to work that day, as I was going to be busy with Christmas preparations for my four-year-old son. Also, I knew that

working on Christmas Eve would be very difficult for any of the store employees, especially the Santaland staff. After all, Santa would go up the chimney at Miller & Rhoads for the last time. It would be a day filled with tears.

On the day before Christmas Eve, I did work at the store, and it was very busy both in Santaland and the Tea Room. The crowds had been huge, as everyone desired one last visit with Santa or one last piece of Rudolph cake.

I had been working as a Snow Queen since 1971. It was almost incredible to think that I would no longer be in the Old Dominion Room the next Christmas season.

On that final Christmas Eve, Colleen and John Deacon decided to go down to the store and observe the visitors who came to see Santa one last time.[98] "Our daughters, Linda and Janice, were grown and were not with us, but we felt the need to just 'be there' on that day," said Mrs. Deacon. "My husband and I sat there for several hours and watched families of three and four generations come through," she said. "We just couldn't leave, and we waited and watched until Santa went up the chimney. We just cried because it was so hard to believe it was the end of the store," she added.

As Santaland staff, we had heard rumors for many years that M&R was experiencing financial difficulties. The store had merged with Garfinkel's of Washington, D.C., in 1967, forming a new corporation known as Garfinkel's, Brooks Brothers, Miller & Rhoads.[99]

In the late 1970s and into the 1980s, the population move was to the suburbs, fueling retail corporate mergers and buyouts. Just as other cities experienced a spiraling down of their retail core, Richmond followed suit. Miller & Rhoads could not recover from sagging sales. In a succession of corporate changes—first with Allied Stores in 1981, then Campeau Corp. in 1986 and lastly Kevin Donahue, a Philadelphia businessman—the store closed in January 1990.[100] It was the end of an era, one that I lovingly refer to now as the "stardust era."

I made a final visit to the store during the "After Christmas Sale" the last week of December 1989. Prices had been slashed, but I really was not interested in shopping. Numbly, I progressed through

Christmas decorations grace Miller & Rhoads's first-floor "under the clock" during the final holiday season, 1989. *Michael Lisicky Private Collection.*

the scores of people who, like me, had come to experience the store one last time. It was obvious that the air was not celebratory, but melancholy.

I traveled by escalator up to the seventh floor and gingerly peeked into the Old Dominion Room, which housed Santaland, now dark. Opening the doors to the room, I secured them so that they would remain open, allowing the light from the hallway to aid my view. The Santaland set was still in place, complete with Santa's throne and the Snow Queen's chair. The shining Christmas tree had not been dismantled. Everything was right where it should be—as if frozen in time—but the room was eerily silent. The echoes of Santa's merry "Ho, Ho, Ho" and the gleeful laughter of children were indelible.

Tiptoeing into the room, almost as if on hallowed ground, I made certain that no one else was present. I stepped up onto the stage, and with tears in my eyes, I took in the scene before me.

As the almost surreal feelings of my childhood rushed past, time stood still. Once again I was six years old. The room was a wonderland; Santa was a treasure the children were seeking; and I dreamed of being the Snow Queen. Then my dream came true, and the many years of being a Snow Queen played back over and over again as a "now showing" classic movie. It had all come full circle.

I sat down in the Snow Queen chair, and holding my face in my hands, I cried in the dark.

Miller & Rhoads's legendary Santa and Snow Queen Donna Deekens, 1982.
Photography by Caston Studios. Bill and Donna Deekens Private Collection.

It was the end of a very special part of my life. It was the death of a store. It was the final chapter of a beautiful story in the life of a proud city. We had captured "stardust in a bottle," if for only a brief moment in time.

But the stardust of that incredible era in the history of Richmond, for thousands of people—the young and those who choose to be perpetually young—still remains. For many, including the Wrenn family, the memories linger and the tradition continues. Dennis and Judy Wrenn wrote:

From the early 1950s until the present [2009] there has always been the yearly holiday pilgrimage to visit the real Santa, whether visiting Miller & Rhoads for nearly fifty years or the Children's Museum for the past few years. Three generations of Harrisons and Wrenns have made this a part of the holiday season that would not be complete at Christmas without this annual rite.

For Judy and Dennis, beginning in the 1950s, there was the trek from Emporia to Richmond with their parents to see Santa and the Snow Queen and eat lunch in the famous Tea Room. Visiting Richmond, with all of the holiday decorations, including the fabulous mechanical window displays and the street and store decorations, made Christmas for small children seem like a magical world that was real and wonderful. This tradition was continued once Dennis and Judy were grown, married and started their family in the 1970s. Their children, Bradford and Bryan, have continued the tradition and now take their own children—our grandchildren—to see the real Santa.

Three generations of children were and have been in awe and amazement that Santa knew their names. For the generations who

Bradford and Bryan Wrenn continued the family tradition of visiting the real Santa at Miller & Rhoads, 1983. *Mr. and Mrs. Dennis Wrenn Private Collection.*

*have visited Santa and the Snow Queen at Miller & Rhoads,
especially during the 1950s through the 1980s, there were
memories made and will be treasured for their entire lives. It was
a true age of innocence for children. And, the atmosphere that
Miller & Rhoads created made all of them, including the adults,
believe in the real Santa, and the true spirit of Christmas.*[101]

This true spirit of Christmas became synonymous with the *real
Santa*, in whom the store and the entire Santaland operation took
such great pride.

Lisa McDaniel Ramos, a Snow Queen in the 1980s, recalled an
experience—only one of many that is endearing to her. She wrote:

*A boy of about eleven or twelve was with a younger brother
and sister visiting Santa. It was obvious the boy had the look
of "what am I doing here" written all over his face. Without
actually expressing himself in words, his face showed he didn't
think there was a Santa. He did actually say he couldn't believe*

Brent Deekens, son of
Snow Queen Donna
Deekens, enjoys a
special moment with
the legendary Santa,
1989. *Bill and Donna
Deekens Private Collection.*

Santa would know their names. Even though he probably heard everybody else having their names called, you should have seen his face when Santa did call his name. He looked at Santa and then me with his mouth a little bit dropped!

My parents used to tell us that as long as you believe, there will always be a Santa Claus. In that moment, it made me smile thinking that maybe just one more year that little boy would believe in the magic of Christmas.[102]

It seems that one more such year can lead to a lifetime. For me, as a Snow Queen, it's been "a wonderful life." I've had a love affair with a beautiful time—the time of the *real Santa* and Christmas at Miller & Rhoads. May this always be a part of me and a part of all those hearts touched by *the magic*...the dreamlike magic of the *stardust* of a heavenly era.

Though I dream in vain,
In my heart it will remain,
My stardust melody,
The memory of love's refrain.[103]

Notes

A Childhood Dream Becomes the Perfect Christmas Job

1. *Richmond Times-Dispatch*, "Miller & Rhoads Santa Schedule," circa November 1989.

The *Real Santa*

2. Francis P. Church, "Is There a Santa Claus?" Editorial, *New York Sun*, September 21, 1897.
3. Kristin Terbush Thrower, *Miller & Rhoads Legendary Santa Claus* (Richmond: Dietz Press, 2002), 80.
4. Earle Dunford and George Bryson, *Under the Clock: The Story of Miller & Rhoads* (Charleston, SC: The History Press, 2008), 69.
5. Clifford Dowdey, "The World's Highest Paid Santa Claus," *Saturday Evening Post*, December 21, 1951, 19, 69.
6. Dowdey, *Saturday Evening Post*, 70.
7. Dowdey, *Saturday Evening Post*, 69–70.
8. Bonnie V. Winston, "You had to be there—Miller & Rhoads and Thalhimers," *Boomer Life* magazine, December 2008–January 2009.
9. Dowdey, *Saturday Evening Post*, 70.
10. Interview with Carolyn Hood Drudge, June 20, 2009.

11. Interview with author, June 20, 2009.
12. Interview with author, May 19, 2009.
13. Interview with author, June 10, 2009.
14. Dunford and Bryson, *Under the Clock*, 69.
15. Dunford and Bryson, *Under the Clock*, 69–70.
16. Letter to author, June 30, 2009.
17. Interview with author, July 6, 2009.
18. Interview with Charles Nuchols, July 3, 2009.
19. Interview with author, May 6, 2009.
20. Interview with Charles Nuchols, July 3, 2009.
21. Telephone interview with author, June 14, 2009.
22. Telephone interview with author, May 30, 2009.
23. Telephone interview with author, April 25, 2009.
24. Dunford and Bryson, *Under the Clock*, 70.
25. Carolanne Griffith Roberts, "Still Santa," *Southern Living*, December 1999.

IT'S ALL ABOUT THE CHILDREN

26. Letter to author, April 29, 2009.
27. Telephone interview with Allen Rhodes, June 8, 2009.
28. Thrower, *Legendary Santa Claus*, 56.
29. Letter to author from Geri Oliver, June 3, 2009.
30. Letter to author, May 8, 2009.
31. Letter to author, July 5, 2009.
32. Interview with author, June 8, 2009.
33. Telephone interview with former Miller & Rhoads executive, May 5, 2009.
34. Telephone interview with former Miller & Rhoads executive, May 5, 2009.
35. Letter to author, June 22, 2009.
36. Letter to author, April 1, 2009.
37. Letter to author, May 11, 2009.
38. Telephone interview with author, May 7, 2009.
39. Letter to author, June 3, 2009.

"HO, HO, HO!": THE HUMOR OF THE CHILDREN

40. Letter to author, April 28, 2009.
41. Letter to author, May 7, 2009.
42. Letter to author, June 29, 2009.
43. Interview with author, June 27, 2009.
44. Interview with author, June 15, 2009.
45. Letter to author, May 10, 2009.
46. Clement Clarke Moore, "The Night Before Christmas."

CHRISTMAS VISITS THAT MELTED THE HEART

47. Dunford and Bryson, *Under the Clock*, 68.
48. Letter to author from Geri Oliver, June 3, 2009.
49. Telephone interview with author, May 16, 2009.
50. Letter to author, June 29, 2009.

THE WONDERS OF THE TEA ROOM

51. Letter to author, June 29, 2009.
52. Letter to author, June 16, 2009.
53. Interview with Charles Nuchols, June 25, 2009.
54. Letter to author, June 1, 2009.
55. Letter to author from Frances Verschuure, June 16, 2009.
56. Interview with author, April 20, 2009.
57. Letter to author, May 7, 2009.
58. Dunford and Bryson, *Under the Clock*, 69.
59. Dunford and Bryson, *Under the Clock*, 68.
60. Telephone interview with author, April 23, 2009.
61. Interview with author, May 18, 2009.
62. A.C. Griffith, "Eddie Weaver at the Mighty Wurlitzer,"
 Richmond Then and Now (www.richmondthenandnow.com),
 June 20, 2009.
63. Dunford and Bryson, *Under the Clock*, 86.
64. Letter to author, May 11, 2009.

65. Letter to author, May 5, 2009.
66. Letter to author, June 2, 2009.
67. Interview with author, April 20, 2009.

Beyond Santaland

68. Interview with William G. Deekens, April 15, 2009.
69. Thrower, *Legendary Santa*, 43–45.
70. Telephone interview with author, June 8, 2009.
71. Telephone interview with Allen Rhodes, June 8, 2009.
72. Dunford and Bryson, *Under the Clock*, 64.
73. Telephone interview with Allen Rhodes, June 8, 2009.
74. Interview with Milton Burke, April 20, 2009.
75. Interview with author, April 20, 2009.
76. Telephone interview with Allen Rhodes, June 8, 2009.
77. Letter to author, June 23, 2009.
78. Thrower, *Legendary Santa*, 113.
79. Letter to author, June 23, 2009.
80. Letter to author, June 16, 2009.
81. Thrower, *Legendary Santa*, 112.
82. Ibid.
83. Letter to author, May 11, 2009.
84. Thrower, *Legendary Santa*, 86–87.
85. Ibid., 86.
86. Telephone interview with author, May 3, 2009.
87. Thrower, *Legendary Santa*, 91.
88. Interview with Charles Nuckols, July 3, 2009.
89. Ibid.

Weary Santa, Tired Snow Queens, Grumpy Elves

90. Interview with author, April 29, 2009.
91. Interview with author, May 11, 2009.
92. Interview with Carol Schlichtherle, May 11, 2009.

93. *Richmond Times-Dispatch*, "Miller & Rhoads Santa Schedule," circa November 1989.
94. Telephone interview with author, May 15, 2009.
95. Interview with Carol Schlichtherle, May 11, 2009.
96. Interview with author, May 11, 2009.

THE ERA OF STARDUST

97. Hoagy Carmichael, music, and Mitchell Parish, lyrics, "Stardust," 1927, Hoagy Carmichael's Orchestra.
98. Telephone interview with author, May 30, 2009.
99. Winston, *Boomer Life*.
100. Ibid.
101. Letter to author, June 10, 2009.
102. Letter to author, June 30, 2009.
103. Carmichael and Parish, "Stardust."

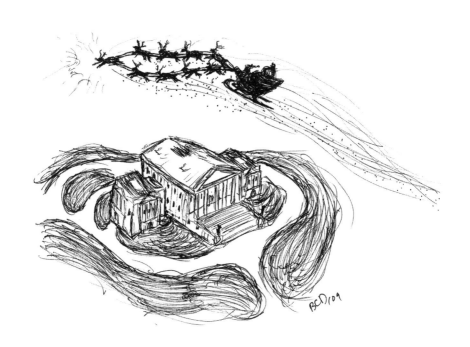

About the Author

Donna Strother Deekens is owner and party director of a traveling tea party business, Teapots, Treats & Traditions. A graduate of Westhampton College of the University of Richmond, she has performed professionally as an actress and soloist. She enjoyed playing the role of Snow Queen for many years at the Miller & Rhoads downtown Richmond department store. In addition to her entertainment background, she has held positions in public relations, marketing and fundraising for governmental, corporate and nonprofit organizations. She is married with two sons.

Visit us at
www.historypress.net